# FEAR NOT!

# Reel Spirituality Monograph Series
## SERIES DESCRIPTION

The Reel Spirituality Monograph Series features a collection of theoretically precise yet readable essays on a diverse set of film-related topics, each of which makes a substantive contribution to the academic exploration of Theology and Film. The series consists of two kinds of works: 1) popular-level introductions to key concepts in and practical applications of the Theology and Film discipline, and 2) methodologically rigorous investigations of theologically significant films, filmmakers, film genres, and topics in cinema studies. The first kind of monograph seeks to introduce the world of Theology and Film to a wider audience. The second seeks to expand the academic resources available to scholars and students of Theology and Film. In both cases, these essays explore the various ways in which "the cinema" (broadly understood to include the variety of audio-visual storytelling forms that continues to evolve along with emerging digital technologies) contributes to the overall shape and trajectory of the contemporary cultural imagination. The larger aim of producing both scholarly and popular-level monographs is to generate a number of resources for enthusiasts, undergraduate and graduate students, and scholars. As such, the Reel Spirituality Monograph Series ultimately exists to encourage the enthusiast to become a more thoughtful student of the cinema and the scholar to become a more passionate viewer.

# FEAR NOT!

## *A Christian Appreciation of Horror Movies*

### Josh Larsen

### Foreword by Soong-Chan Rah

CASCADE *Books* • Eugene, Oregon

FEAR NOT!
A Christian Appreciation of Horror Movies

Copyright © 2023 Josh Larsen. All rights reserved. Except for brief
quotations in critical publications or reviews, no part of this book may
be reproduced in any manner without prior written permission from
the publisher. Write: Permissions, Wipf and Stock Publishers, 199 W.
8th Ave., Suite 3, Eugene, OR 97401.

Cascade Books
An Imprint of Wipf and Stock Publishers
199 W. 8th Ave., Suite 3
Eugene, OR 97401

www.wipfandstock.com

PAPERBACK ISBN: 978-1-6667-3852-0
HARDCOVER ISBN: 978-1-6667-9935-4
EBOOK ISBN: 978-1-6667-9936-1

## Cataloguing-in-Publication data:

Names: Larsen, Josh, author. | Rah, Soong-Chan, foreword.

Title: Fear not! : a Christian appreciation of horror movies / Josh Larsen;
   foreword by Soong-Chan Rah.

Description: Eugene, OR: Cascade Books, 2023 | Reel Spirituality Mono-
   graph Series | Includes bibliographical references.

Identifiers: ISBN 978-1-6667-3852-0 (paperback) | ISBN 978-1-6667-9935-4
   (hardcover) | ISBN 978-1-6667-9936-1 (ebook)

Subjects: LCSH: Horror films—Criticism and interpretation. | Christian life.
   | Occultism—Religious aspects—Christianity.

Classification: BV4501.3 L364 2023 (paperback) | BV4501 (ebook)

VERSION NUMBER 061223

All Scripture quotations, unless otherwise indicated, are taken from
the Holy Bible, New International Version®, NIV®. Copyright ©1973,
1978, 1984, 2011 by Biblica, Inc.™ Used by permission of Zondervan.
All rights reserved worldwide. www.zondervan.com The "NIV" and
"New International Version" are trademarks registered in the United
States Patent and Trademark Office by Biblica, Inc.™

Dedicated to the *Think Christian* community:
readers, listeners, viewers, commenters, contributors,
colleagues, donors. There's no such thing as secular.

# CONTENTS

*Foreword by Soong-Chan Rah* | ix
*Acknowledgments* | xi

Introduction: The Only Thing We Have to Fear Is . . . a Lot | 1

Monster Movies: Fear of Our Own Capacity for Sin | 11

Zombies: Fear of Losing Our Individuality | 19

Creature Features: Fear of Nature Run Amok | 27

Slashers: Fear of Being Alone | 36

Religious Horror: Fear of a Spiritual Realm | 44

Sex and Death: Fear of Sexuality | 53

Found Footage: Fear of the Dark | 61

Body Horror: Fear of This Mortal Coil | 69

Prophetic Horror: Fear of Societal Evil | 77

Psychological Horror: Fear of Our Anxieties | 85

Ghost Stories: Fear of Guilt | 92

Conclusion | 102

*Bibliography* | 103
*Index of Movie Titles* | 105

# FOREWORD

A brown wicker bassinet slowly rotated on the television screen, gradually revealing a deformed hand hanging over the edge of the crib. The sound of a heartbeat could be heard in the background. The voice-over narration was muted but hinted of unspeakable horrors at the hands of the monster baby in the crib. More than forty-five years later, I still vividly remember the feeling of watching that horrifying commercial for the movie *It's Alive*. I never saw the movie, but my nine-year-old self was convinced that this was the scariest story ever told. Even now as I write about that commercial, I still get goosebumps and I find myself looking around my home office wondering why it's so dark in here. How does fear stick to our soul so profoundly that a middle-aged, AARP-eligible professor still has a deep, visceral reaction, nearly half a century later? Because strong emotions like fear have power.

As a professor of evangelism, I try to teach students who strive to be spiritual leaders and ministers how to communicate the message of the gospel, but not merely with words. I also try to help them learn how to make the message stick—not only in the mind, but in the heart, soul, and spirit. Most of our gospel communication is rather pedestrian, evoking philosophical ideas and arguments but

not much of anything else. It doesn't stick because it doesn't demand much from our imagination, our hearts and our souls. But the gospel message is so much more than just cognitive acquiescence to propositional truth.

In this book, Josh Larsen reminds us of that truth. Connecting to our spirit can be accomplished not only with the right words, but with real emotions felt in the mind, soul, and body. Larsen reminds us that the films in the horror genre can and do evoke a visceral experience that moves beyond the rational and the cognitive. From Larsen's viewpoint, imagination and emotions are not barriers to the gospel; they are entry points. That connection may open up a necessary doorway to spirituality that so often eludes the contemporary Christian. Christian faith should engage the entirety of the human experience, speaking biblical truth that recognizes both the joyful and even the horrific.

So read this book with all the lights on . . . and with your heart racing and your bodily memory on full alert. And ask yourself: Can God be found in the middle of my most profound fears? Do I actually believe that God is in the middle of my story, even my horror story? I'll let you know my answer if I can ever again get a full night of sleep after watching *Skinamarink*.

Soong-Chan Rah
Robert Munger Professor of Evangelism
Fuller Theological Seminary

# ACKNOWLEDGMENTS

I like to think this book was born at the 2015 Sundance Film Festival, where Elijah Davidson and I sat together at a midnight screening of *The Witch*, from then-unknown filmmaker Robert Eggers. We separated after that harrowing movie, well into the night, which was unfortunate. I could have used his company on my lonely walk back to my host home, under a bright moon and a dark landscape dominated by trees bereft of leaves. Eggers's witch was watching me, I'm sure of it.

It was Elijah, co-director of Fuller Theological Seminary's Brehm Film, who invited me some seven years later to contribute a book on horror to Brehm's Reel Spirituality Monograph Series. I was honored and intrigued, so along with another Brehm co-director, Kutter Callaway, we devised a plan for *Fear Not! A Christian Appreciation of Horror Movies*. I'd like to thank them both for their faith in me, astute guidance as editors, and overall gracious presence in the world of faith and film. Thanks as well to the folks at Cascade Books, who have provided a nurturing space for the books in the Reel Spirituality series.

This was a different project than my first book, *Movies Are Prayers*, in that my wife, Debbie, and two daughters, Adeline and Beatrix, were less inclined to join me in

watching movies as research. (Horror isn't exactly their thing.) So I thank them for their patience and apologize for all the screaming and distressing music that frequently came from the next room. Thanks too to Debbie, for assuring me that we could weather the time away from family that a book inevitably requires.

As an editor herself in a former life, Debbie was also one of the confidantes who helped me bushwack my way through the most challenging chapter of the book: "Found Footage." Joel Mayward, author of *The Dardenne Brothers' Cinematic Parables*, also provided feedback, while Elijah suggested incorporating the notion of real-life cell phone footage, which he knew was an area of interest for me. That idea cut enough of a path to get out of the chapter alive.

Joe George, a key contributor to *Think Christian* and an astute observer of the horror genre, was also kind enough to give the manuscript a read and flag any contextual or factual missteps I may have made. If there's a boneheaded mischaracterization in the book, blame him. (Just kidding. Joe's also an expert in the superhero genre and I highly recommend his own work of Christian arts criticism: *The Superpowers and the Glory*.)

While most of my work is in Christian media, I've been fortunate, since 2012, to also be part of the larger film conversation as co-host of *Filmspotting*, the podcast and Chicago radio program. Executive producer Adam Kempenaar, also my on-air partner, and producer Sam Van Hallgren—who launched the show together in 2005—never fail to keep me on my toes with big ideas, critical acumen, and the continually humbling reminder that good criticism means community.

As to that Christian media arena, my professional home since 2011 has been ReFrame Ministries, where I've led the faith-and-culture program *Think Christian*. I can't

imagine another place, especially under the leadership of our English team co-directors Robin Basselin and Justin Sterenberg, that would so graciously have me, or a project like *Think Christian*, that would be so fitting to whatever strange jumble of gifts God has given me. I've been doing this long enough now to look back with astonishment at the little niche God has carved out for me to work within. I praise a generous Creator who fashioned us as creative beings, enabling us to tell stories of all kinds, in many forms, that at their best declare good news of an almost unfathomable kind.

# INTRODUCTION

## THE ONLY THING WE HAVE TO FEAR IS . . . A LOT

"*Why would you want to watch that?*"

Any fan of horror films has likely been asked this at some point in their life. It's a fair question. The horror genre provokes anxieties, gravitates toward grisliness, and frequently exploits sex and violence. Why would you watch something that makes you wince?

It's a wonder I haven't run away from horror as an adult, given how I was introduced to it at an early age—too early. While I was growing up, my mother's extended family had an intergenerational tradition of gathering at one of her aunts' houses on Sunday nights, after the evening church service. While the adults indistinctly yammered in another room like the grown-ups in a Charlie Brown cartoon, we kids would play games and eat ham buns, keeping to ourselves. As the night wound on and the younger children started dropping off to sleep, the older cousins often ended up in front of a basement television set. I distinctly remember the couple of times we stumbled upon horror. These being the days of network television, we admittedly

1

saw "edited-for-TV" versions of the films, but let me assure you: any presentation of *Psycho* or *The Shining* makes an indelible impression, even with commercial interruptions.

And so my first experiences with horror were not academic, but visceral. Shower curtains and empty hotel hallways would never be the same. Taking a shower *in* an empty hotel room? Let's not even talk about it. Why, then, as a discerning adult, would I still want to watch this? More pointedly, why did I pursue a career in film criticism, with a fondness for horror in particular?

Frankly, I don't see how you can be a serious fan of film and not appreciate horror. If *method* is as much a part of the art form as *meaning*, then few genres are as fertile a playground for playing with film form as horror. (Musicals, maybe?) As soon as I realized that talented artists made creative decisions that resulted in my most powerful moviegoing experiences, I also recognized that some of the most exciting choices were being made in the realm of horror.

Take *Psycho*, for instance. (As the saying goes and will be true throughout this book: spoilers ahead.) Alfred Hitchcock's 1960 slasher follows an embezzling woman on the run who has the bad luck of renting a motel room from a man with a severe, violent, and exaggerated case of dissociative identity disorder. The killing of Marion Crane (Janet Leigh) as she showers in her room is terrifying not just because of what it's about (*murder!*), but—to paraphrase the great film critic Roger Ebert[1]—because of *how* it's about it. Orchestrating George Tomas's cutting edits and Bernard Herrmann's stabbing score, Hitchcock creates a symphony of shock cinema without ever showing the slicing of skin. And let's also give Leigh credit for evoking an eerie deadness in the sequence's final image, when the camera—echoing

1. Fragoso, "TIFF 2015," lines 1–2.

the preceding shot of bloody water circling the drain—slowly revolves around Marion's open, lifeless eye.

Similarly, in the case of 1980's *The Shining*—Stanley Kubrick's adaptation of the Stephen King novel about a caretaker and his family staying alone in a remote resort over the offseason—the story is less disturbing than the filmmaking. The sequences of young Danny (Danny Lloyd) riding his tricycle down the byzantine hallways of the hotel are captured via the brilliant use of a Steadicam, a stabilizing apparatus for movie cameras that allows for smooth, unbroken shots moving through a scene. Cinematographer John Alcott and Steadicam operator (and inventor) Garrett Brown—the latter conducting the camera while sitting in a wheelchair—increase the anxiousness and apprehension of these scenes by manipulating speed and distance to various degrees. And all this before Danny turns a corner to come face-to-face with the ghostly Grady twins. (Adding to my personal fear of *The Shining* was the fact that when I first saw it on TV on one of those Sunday nights in the 1980s, I was the spitting image of little Danny Lloyd.)

As a budding cinephile, then, I was easily hooked on horror, despite my abrupt childhood introduction to the genre. But what about as a *Christian* cinephile? Shouldn't followers of Jesus, in particular, ask, "Why would you want to watch movies full of murder and mayhem?"

Often when I'm asked this, the person making the query brings up Philippians 4:8: "Finally, brothers and sisters, whatever is true, whatever is noble, whatever is right, whatever is pure, whatever is lovely, whatever is admirable—if anything is excellent or praiseworthy—think about such things." Not exactly the qualities that come to mind while zombies are munching on flesh in *Night of the Living Dead* or Leatherface is swinging power tools around in *The Texas Chain Saw Massacre*.

It's helpful to keep in mind, however, that Paul's letter to the church in Philippi was not intended to chide or correct, like other missives sent by the apostle to churches in crisis. Rather, the Philippians were a source of inspiration for Paul. While in political custody, he wrote to them to thank them for their "partnership in the gospel" (Phil 1:5) and to assuage their own fears (Phil 1:12–30) about his fate as a prisoner. And so his citation of the qualities in Philippians 4:8—"whatever is true, whatever is noble, whatever is right, whatever is pure, whatever is lovely, whatever is admirable"—is not meant to chastise his audience because they had been pursuing other, "unholy" things, but to encourage them to overcome the fear they held by seeking such qualities. Horror films encompass both the fear *and* the admiration. Not only do these movies honestly acknowledge that which terrifies us, but the most redemptive of them—the ones explored in this book—do so with an artistry that is true, noble, and admirable. Some of them even take us to the other side of our fears, to a lovely place of grace.

If Paul urged the church in Philippi not to be anxious— to fear not!—he did so with a clear understanding of the realities of his imprisonment and the horror that faced him. Such honesty about the terrors of this life is found throughout the Bible. Murder slashes into God's grand narrative as soon as the fourth chapter of Genesis, when Cain tricks and then kills his brother, Abel. (Like a ghost, Abel continues to haunt Scripture, from the way his "blood cries out" in Genesis 4:10 to the eulogies of Matthew 23:35 and Hebrews 11:4.) Then there is the zombie army raised by Ezekiel at God's command in Ezekiel 37:1–10: "And as I was prophesying, there was a noise, a rattling sound, and the bones came together, bone to bone. I looked, and tendons

and flesh appeared on them and skin covered them . . ." Call it reverse body horror.

Throughout Scripture, demons sneak onto the scene, perhaps most terrifying in Jesus' encounter with the man possessed by Legion—so named because "we are many" (Mark 5:9). Like little Regan MacNeil in *The Exorcist*, whose tiny body becomes a sadistic tool in the claws of her demonic possessor, it's the pitiable state of the possessed man that has always shaken me. "Night and day among the tombs and in the hills he would cry out and cut himself with stones," we're told in Mark 5:5.

These Bible stories have varied purposes, but they share at least one thing in common: they evoke and consider fear. Fear of vengeance and violence. Fear of our mortal flesh. Fear of our faulty minds. Fear of a spiritual realm we cannot fully comprehend. No one really wants to "think about such things," to reference Philippians 4:8 again, but we live them. And one of the reasons the Bible remains a vital document, thousands of years on, is because it encompasses the entirety of our human experience, both the lovely moments and the ghastly ones.

The world, after all, is a frightening place, in ways big and small, existential and intimate. A basic claim of this book is that Christianity speaks specifically to our fears. In a 1933 sermon entitled "Overcoming Fear," Dietrich Bonhoeffer reflected on another scary story from Scripture: the "furious storm" of Matthew 8. This tempest threatens to drown the disciples until Jesus, after being roused from his sleep, magisterially calms the calamity. Bonhoeffer wrote:

> Fear is, somehow or other, the archenemy itself. It crouches in people's hearts. It hollows out their insides, until their resistance and strength are spent and they suddenly break down. Fear secretly gnaws and eats away at all the ties that

bind a person to God and to others, and when in
a time of need that person reaches for those ties
and clings to them, they break and the individu-
al sinks back into himself or herself, helpless and
despairing, while hell rejoices.[2]

That's grim, visceral stuff. But it's also true. These
honest, vulnerable observations come from a man
who faced historical, world-shaking fears, considering
Bonhoeffer was a German Lutheran pastor who opposed
the Nazi regime and was executed in a POW camp. Yet his
sermon also speaks to timeless, universal fears—of illness,
which he later references in his sermon—as well as primal
ones (of violent storms, say, or the dark).

Strikingly, Bonhoeffer doesn't deny our fears. He
acknowledges them, just as Matthew 8 acknowledges the
harrowing wind and waves of the storm. This suggests that
the clear articulation of fear is a more Christian response
than the repression of it. Horror in the Bible acknowledges
the deep-seated terror we experience in this broken world.
To sweep away such fear runs against the grain of Scripture.
"Those who would try to keep up their pride, as if all this
had nothing to do with them, as if they didn't understand
what it's all about, would hardly be human," Bonhoeffer
wrote.[3]

Horror, then, is a crucial genre for Christians. Scott
Derrickson, a Christian and a filmmaker whose credits as
director include both the horror hit *The Exorcism of Emily
Rose* and the Marvel Cinematic Universe installment *Doctor
Strange*, has described horror as "the genre of non-denial."[4]
Speaking to critic Steven D. Greydanus at the *National
Catholic Register*, Derrickson added, "I think we need

2. Best, ed., *Collected Sermons of Dietrich Bonhoeffer*, 60.

3. Best, ed., *Collected Sermons of Dietrich Bonhoeffer*, 62.

4. Greydanus, "Interview," line 12.

cinema to break that apart and remind us that we're not in control, and we don't understand as much as we think we do."[5] Perhaps that's something of what Jesus meant when he asked the disciples, after the storm subsided, "Why are you so afraid?" (Matt 8:26). We have to ask ourselves that question—be honest about and humbled by our fears—in order to be open to the comfort offered by the gospel.

How do horror movies do both: express our fears and answer them, in a manner that resonates with the hope of the good news of Jesus Christ? That's the project of this book, to examine how certain fright films resonate with our broken experience—in artistically true, noble, and admirable ways—while also hinting at God's redemptive promise.

## How to Decide What to Watch

With such a specific goal, there is no way to be comprehensive—especially with a genre as varied and far-ranging as horror. And so some classics, as well as some seminal filmmakers, may only be mentioned in passing or not discussed at all. It's no slight or oversight, just a symptom of the book's strategy and structure. I've devoted each of the chapters that follow to a different horror subgenre, connecting each subgenre to a commonly shared fear. (Again, notable titles within the subgenre that don't touch on that specific fear will likely not be incorporated.) In addition to considering how the Bible acknowledges and speaks to that fear, each chapter examines a handful of films to show how their related themes, narratives, and aesthetics can be viewed through a corresponding theological lens.

5. Greydanus, "Interview," lines 16–18.

One word of warning. As has likely already become obvious, the horror genre lives and breathes challenging content. Violence—if not physical, then of the psychological variety—drives the genre. Explicit sexuality works its way into the mix, sometimes pointedly, often unnecessarily. Religious horror relies on and at times revels in sacrilege. And so a brief discussion of discernment will be helpful.

I think of discernment as something that is personal, yet best done in community. By personal, I mean this: content that might cause one Christian to stumble, given their particular struggles, addictions, or temptations, may not be troubling to another. Just because a certain film might spiritually derail me—blot out my ability to even see that which is also lovely and admirable—doesn't mean I have the duty to prevent others from watching it. Christians have freedom both ways: freedom to engage with certain films and freedom not to, depending on their own discernment. And yet, because as broken humans we often lie to ourselves (perhaps especially when it comes to discernment), we should watch such challenging films alongside fellow followers of Jesus who can hold us accountable: good friends, spouses, church movie groups, and the like.

## Do Not Be Afraid

As many readers likely know, this book's title references one of the most frequently offered encouragements in the Bible: Fear not! (Or, in other translations: Do not be afraid!) We hear it from the mouths of prophets, speaking to the shuddering nation of Israel; in the words of angels, announcing Christ's birth to quaking shepherds and later his resurrection to incredulous followers; and from the lips of Jesus himself a number of times, including to the father

of a daughter on death's door. In each case the fears—the horrors—these people face may be slightly different, but the biblical response is the same. God—who is bigger than our fears and more powerful than what we fear—is with us, in the person of Jesus Christ, who knows what it is to be afraid given what he endured on the cross.

All fearfulness stems from a common, theological root: a deep uneasiness over our separation from God and the broken world that is the result. Christ experienced that separation firsthand at Calvary, an event so horrific it is chronicled in Matthew 27 alongside darkening skies, splitting rocks, and the dead emerging from their tombs. And yet, after enduring such abandonment on our behalf, Christ rose to demonstrate that horror will not have the final say. As Bonhoeffer preached: "We name the one who overcame fear and led it captive in the victory procession, who nailed it to the cross and committed it to oblivion; we name the One who is the shout of victory of humankind redeemed from the fear of death—Jesus Christ, the Crucified and Living One."[6]

Yes, but such words may not offer comfort when we're truly, deeply scared—when we can't catch our breath. When was the last time you were terrified like that?

I've led a fairly protected life, so the most frightened I've ever been has been over something fairly silly. I'm guessing I was in middle school, maybe younger, at a family reunion at a Michigan lake, where a vast stretch of sand dunes sat across the water from the cozy cottages. A cousin and I decided to pitch a tent on the dunes one night, at the top of a sandy hill. Late into the evening—the moon full enough to transform a dozen wolf men—we heard low voices and odd growls surrounding the tent, inching ever closer. Then the attack came, flipping the tent, sending it

6. Best, ed., *Collected Sermons of Dietrich Bonhoeffer*, 61.

rolling down the sandy hill, where we lay in a quaking, discombobulated pile until the early morning, too terrified to try and dig our way out. We discovered the culprits the next day: a prankish aunt and a cadre of cackling older cousins.

What I mostly remember, balled up there in that tent, was the feeling of surrender. I was helpless in a visceral way I had not felt before or since. This is where horror takes us: to that place of surrender, where what some consider to be the platitudes of Christianese suddenly have real power, because we have no other choice. In horror, there is humility. And in our humility, the good news of the gospel offers true comfort, because it arrives from completely outside of ourselves, despite ourselves. As my pastor, Roger Nelson, wrote in a 2022 sermon on Isaiah 43:

> God doesn't promise that we'll be protected from those things that rightly scare us. We'll still be overwhelmed by the waters, singed by the fire, and struggle on the journey. Being created and redeemed by God doesn't spare us from dying of cancer, getting hit by a car, or struggling with depression. But the word of God through Isaiah is that we don't face those realities alone. . . . At birth, death, and resurrection, you belong to God. At birth, death, and resurrection, don't be afraid.[7]

So, why would I want to watch that? Let me show you . . .

---

7. Nelson, "Industries of Fear," lines 112–21.

# MONSTER MOVIES

## FEAR OF OUR OWN CAPACITY FOR SIN

Horror begins at home. On some days, we fear ourselves the most—or at least the things we know we're capable of. Even those who have never considered committing any sort of crime know that a few, if not all, of the deadly sins still lurk somewhere in our hearts. What if we were to let one off the leash?

In the midst of his struggle with lycanthropy—the belief that you're a werewolf—Larry Talbot goes to church. This is well into 1941's *The Wolf Man*, after Talbot (Lon Chaney Jr.), an aristocratic Welshman turned werewolf, has killed a gravedigger while under the influence of the night. Dazed and confused the next morning, he stands at the back of the cathedral, hat nervously in hand. Director George Waggner's camera then tracks down the aisle, the villagers in the pews turning around to look at Larry as the camera passes by each row. (They've heard the midnight howling, as well as the rumors.) The shot comes to a rest on the incriminating face of the town's constable, before we eventually settle on the perplexed visage of Larry's father,

Sir John Talbot. He's sitting in the front row, saving a seat for his son. But Larry flees.

## Men Are Monsters

"I do not understand what I do," Paul confesses in Romans 7:15. "For what I want to do I do not do, but what I hate I do." Like the disheveled Larry Talbot awakening in his bed—baffled by the muddy paw prints on the sill of his open window, yet knowing deep down that they lead to him—Paul finds himself trapped by sin. Even as an apostle, he's seemingly split between two selves. "For I do not do the good I want to do, but the evil I do not want to do—this I keep on doing," he writes in Romans 7:19. This is what Larry Talbot fears, what we all fear.

Fear of our own capacity for sin can be found throughout the classic horror films distributed by Universal Pictures from the 1930s to the 1950s. Titles such as *Dracula*, *Frankenstein*, *The Mummy*, *The Invisible Man*, and—my personal favorite—*Creature from the Black Lagoon* all function as monstrous mirrors. Give the Wolf Man a shave, unravel the Mummy's wrappings, make the Invisible Man visible, and what do we find? Ourselves—doing not what we know we should do, but what we know we should not.

In *Devouring Whirlwind: Terror and Transcendence in the Cinema of Cruelty*, Will H. Rockett writes this of monster movies: "Audiences may identify with the semi-demonic force that is in some way recognizably human (for example, the werewolf or the vampire), and vicariously accept its punishment (with the silver bullet or the stake) as their own."[1] These creatures, however, fare poorly as actors of atonement on our behalf. Count Dracula is no Christ

1. Rockett, *Devouring Whirlwind*, 3.

figure. They're more potent as ghoulish self-portraits; Dracula's desire to drink blood stands in for our various urges to transgress against God's will in some way.

God clearly set the boundaries in the earliest chapters of the Bible. Adam and Eve were not to eat of the tree of the knowledge of good and evil; such things are reserved for God. As with all of the precepts given to us by a loving Creator, our protection is part of the purpose. Eating of the tree may have given us knowledge—power—but it's a power, as created beings, we cannot handle. Consider, after all, the power grabs we see in these Universal films, as well as the tragic results.

Dracula has been envisioned many times on the big screen, perhaps most memorably in 1931 by Bela Lugosi. In *Dracula*, directed by Tod Browning, Lugosi's Transylvanian count has an elegant, gentlemanly demeanor meant to distract us from his true nature: that of a monstrous sexual predator. (Perhaps the three imprisoned "brides" we meet early on at his castle should have been a clue.) Dracula preys primarily on young women, in a way that should especially trouble anyone who has been tempted to pursue sexual gratification through the exertion of power—physical or otherwise. Lugosi's Dracula compels women to surrender themselves by sheer force of his dark charisma. It's a seductive, reductive, dark fantasy of how sexual relationships should work, in which everything is taken by the domineering partner and nothing is given in return.

Two of Dracula's "conquests" illustrate this well. In the first, an immaculately dressed Count Dracula devours a scraggly young flower seller on the street while en route to the opera. As he lowers her menacingly out of the camera's frame (we never see the bite), it's clear that class dynamics partly allow him to commit such a brazen act in public. Later, among his own upper class, all he has to do

to entrap a mesmerized Mina Seward (Helen Chandler) is stand imperiously with his cape opened wide. Under his spell, she willingly walks forward until she's enveloped in its darkness. It's a puissant horror image, as well as a troubling metaphor for the ways those in positions of power can be tempted to leverage it for sexual gain.

In 1931's *Frankenstein*, the title scientist (Colin Clive) strives to do nothing less than create life. (Who needs the trees of Eden?) The resulting murderous monster may be killed by villagers, but that gives me no comfort at the movie's end. If anything, my sympathies lie with the poor creature, given the legendary Boris Karloff's dignified performance, all sad eyes and limp limbs. I'm never really afraid of Karloff's lost, lurching orphan. Rather it's Dr. Frankenstein himself, who survives the film, who serves as a haunting reminder of my own tendency to think that I can do God one better.

The madman grasping for power in 1932's *The Mummy* doesn't fare as well as Dr. Frankenstein. This time, Karloff unequivocally plays the villain: the ancient Egyptian priest Imhotep, who is unwittingly revived by British archeologists early in the movie and proceeds to hypnotize and kill. In a flashback thousands of years prior, we learn that Imhotep was condemned by the pharaoh for trying to cast a spell of resurrection. His sentence? To be mummified alive. As strips of cloth are wrapped around Karloff's bulging eyes and gaping mouth, an awful irony sinks in: Imhotep, who sought eternal life, will soon wish he could die instead.

Even more maniacal than Dr. Frankenstein and Imhotep is Jack Griffin (Claude Rains), the title scientist of 1933's *The Invisible Man* (directed, like *Frankenstein*, by James Whale). Among Griffin's ravings is the biblically tinged claim that his invisibility gives him the "power . . . to walk into the holy of holies!" Yet given that Griffin's

world-dominating plans barely progress beyond a small English village, the "emptiness" of the movie's invisible imagery also works as a commentary on the character. When a seemingly unoccupied suit walks across the screen, we're impressed by the early technical trickery, but also aware that Griffin's megalomaniacal delusions of grandeur are, quite literally, a mirage of invincibility. In the end, Griffin becomes visible—at first his skull and then his skin—on his deathbed.

This lusting for power on the part of ancient priests and mad scientists may be somewhat hard to identify with. Unlike Rains's Jack Griffin, I've never really been tempted to sell a secret formula to the highest bidder for the purpose of creating an invisible army. But what about just plain lust?

## Monsters Are Men

The first time I saw 1954's *Creature from the Black Lagoon*—on TV as a child, wearing the flimsy, cardboard 3D glasses provided by a convenience store, as some sort of promotional tie-in with the local TV station—I was too young to pick up on the lasciviousness of the title monster. I just thought that this "gill man," a prehistoric, biped fish person that glides through the waters of the Amazon River, seaweed trailing him like primordial coattails, looked incredibly cool. But to adult eyes, the film's alluringly choreographed underwater ballet sequence, in which the creature watches from below as Julie Adams swims along the water's surface, is also liquidly erotic, a horror variation on King David's leering over Bathsheba as she takes her own bath.

Despite his voyeurism, this gill man—portrayed by Ricou Browning in the underwater sequences—straddles the line between the predatory monstrosity of Dracula and the sympathetic sadness of Dr. Frankenstein's monster.

15

The creature is terrible, but also tragic. Equally troubling (and self-incriminating) are the scientists who disturb and provoke the gill man in his hidden Amazonian lagoon, instinctively resorting to retributive violence when the creature attempts to defend its territory. In this sense, they're similar to *Frankenstein*'s villagers, wielding pitchforks and torches, looking to extinguish the misunderstood "other." Often in these Universal horror pictures, the humans are the monsters, revealing another sort of sin we should be fearful of: our urge to be part of the self-righteous mob.

In *The Wolf Man*, villagers with torches also come after Lon Chaney Jr.'s Larry Talbot. Talbot offers a much more complicated picture of the "manimal" predator than the gill man. As that scene in the church suggests, Larry is a monster with a troubled moral conscience. The movie makes it clear at the very beginning that he's no innocent. After helping his father construct a giant telescope in the library of their estate, Larry trains the lens toward the village below. He quickly finds an open window, revealing Gwen Conliffe (Evelyn Ankers) primping in the bedroom above the antique shop she runs with her father. (More voyeurism.) Larry runs down to the village in no time, approaching Gwen in the shop and creepily commenting on the earrings he saw her wearing through the telescope. He proceeds to repeatedly ask Gwen on a date, even after she refuses, and shows up that evening to take her out against her wishes. Larry hasn't even been bitten yet and the fur is starting to grow.

As such, Larry has little chance of resisting his own worst impulses once he's attacked by a wolf, not long after meeting Gwen. (Amusingly, especially for Universal horror fans, the "gypsy"-turned-wolf who bites him is played in a cameo by 1931's Dracula, Bela Lugosi.) According to a local poem that is cited three times in the film, no man, no

matter how good, could hold his moral ground while under the curse of the wolf: "Even a man who is pure in heart and says his prayers by night / May become a wolf when the wolfbane blooms and the autumn moon is bright." (Larry, I suspect, lacks a robust prayer life.)

That poem recalls Paul's letter to the Romans, no? In Romans 7:22–24 Paul writes, "For in my inner being I delight in God's law; but I see another law at work in me, waging war against the law of my mind and making me a prisoner of the law of sin at work within me. What a wretched man I am!" As he frantically scampers through the woods, blood on his hated paws, Chaney reflects this wretchedness in his wide eyes, which bulge beneath the bushy fur that has overtaken his face. Without releasing him from culpability for his actions, we can still recognize that this isn't the expression of a fearsome, amoral predator (a Dracula), but a man horrified by the depths of his own sin.

As in *Dracula* and *The Invisible Man*, power also comes into play. As the son of a nobleman, Sir John Talbot (Claude Rains again), Larry enjoys a layer of protection, no matter what the villagers or the constable may suspect. Indeed, Col. Montford (Ralph Bellamy), the constable, holds most of his investigation meetings in the lavish drawing room of the Talbot estate, with Sir John on hand. For his part, Sir John remains willfully oblivious to his son's complicity, even as Gwen inches closer and closer to becoming a victim of Larry's bloodlust. The nearest Sir Talbot comes to acknowledging the possibility that Larry might be dangerous is a quip about "the good and evil in every man's soul."

If Paul convicts all of us in Romans—himself, as well as the likes of Larry Talbot—he also offers gospel hope later in the letter. In Romans 8:1–2, he writes, "Therefore, there

is now no condemnation for those who are in Christ Jesus, because through Christ Jesus the law of the Spirit who gives life has set you free from the law of sin and death."

A somewhat similar word of grace is offered to Larry in *The Wolf Man*'s final moments. Despite his attempts to resist the sin within—even begging his father to tie him to a chair after the sun goes down—a horrible thing happens. In the darkness of the foggy forest (the gray, murky cinematography by Joseph A. Valentine eerily evokes the movie's moral muddiness), a feral Larry in full wolf form attacks Gwen. His father, Sir John, kills the animal, then watches in horror as an itinerant woman (Maria Ouspenskaya)—the mother of Lugosi's wolf man from earlier in the film—arrives out of the darkness to offer this blessing over Larry as he slowly returns to his human state: "The way you walked was thorny, through no fault of your own. But as the rain enters the soil, the river enters the sea, so tears run to a predestined end. Your suffering is over. Now you will find peace for eternity."

We could quibble with the theology here; surely the apostle Paul would. Yet as someone who finds these Universal horror pictures not only cinematically enthralling but also frightfully convicting, I understand *The Wolf Man*'s howl as a cry for the good news.

# ZOMBIES

## FEAR OF LOSING OUR INDIVIDUALITY

Zombie movies may be among the most gruesome entries in the horror genre, but it usually isn't the viscera that I find the most disturbing. For me, it's the inevitable scene in which a character helplessly stands by as a loved one "turns"—life draining from their eyes, to be replaced by a glassy stare or, in some cases, a violently bloody glare.

In *Train to Busan*, a 2016 Korean zombie flick directed by Yeon Sang-ho, this happens over the phone. Seok-woo (Gong Yoo), a workaholic fund manager, has boarded a train to bring his young daughter (Kim Su-an) to visit his wife, from whom he's recently separated. When news of a zombie outbreak begins spreading through the train car, he calls to check on his mother. Although she tries to sound calm (the camera never leaves Seok-woo's face as he listens), he can immediately tell something is wrong with her. We too can hear it in her voice, the humanity draining away with each gag and gurgle. Her kindly intonation eventually gives way to something sinister and ravenous, culminating

in an uncharacteristically angry reference to Seok-woo's wife as a "bitch."

## Patient Zero

The cause of a zombie outbreak varies from film to film. In 1968's *Night of the Living Dead*, directed by George A. Romero (considered the grandfather of the modern zombie movie), it was radiation from outer space. In 2002's *28 Days Later*, it was a virus that had been injected into chimpanzees as part of torturous medical experiments. A leak at a biotech plant—whose stock Seok-woo trades in—is the culprit in *Train to Busan*. Whatever the root cause and whatever variety of zombies are the result—the trudging ghouls in *Night of the Living Dead* or the scampering speedsters of *28 Days Later* and *Train to Busan*—the existential effect on the viewer is the same: such movies explicitly illustrate our fear of losing our autonomy, our individuality, our very humanity. Zombie films explore our fear of becoming mindless, grasping automatons, devoid of that which makes us . . . well, us.

For Christians, there is another layer to such terror. The "undead" no longer carry their identity as image bearers, something theologians refer to as the *imago Dei*. This understanding of humankind not only sets us apart from the rest of God's creatures, but suggests that we are even drawn from God's own being, as described in Genesis 1:26: "Then God said, 'Let us make man in our image, after our likeness. And let them have dominion over the fish of the sea and over the birds of the heavens and over the livestock and over all the earth and over every creeping thing that creeps on the earth.'" Romero's zombies certainly creep; it's as if being bitten in one of his movies knocks you down the creational ladder.

The logistics of a zombie movie are usually fairly straightforward: don't get attacked and you'll remain human. In real life, however, the things that "turn" us can be sneakier. We deny the *imago Dei* whenever we pivot from that which makes us uniquely gifted participants in the flourishing of creation and turn toward something that reduces us to just another body in a rapacious, single-minded horde. Consider consumerism; when we root our identity in the material goods we grasp after (especially those goods produced via exploitation and violence), we're not much different than the zombies who wander through the shopping mall in Romero's *Dawn of the Dead.* Or how about the time we spend amusing ourselves to undeath? Sitting slack-jawed, without discernment, before hours and hours of content on our screens, we're like the line of bus passengers staring at their phones early on in Edgar Wright's 2004 zombie comedy *Shaun of the Dead.* (At this point in the movie, they haven't even been bitten.)

Later in *Shaun of the Dead*, one survivor describes the zombies this way: "Look at the face. It's vacant . . . with a hint of sadness." That's actually more of a recognition of the *imago Dei* than zombies usually get. In *Train to Busan*, a businessman asks at the start of the outbreak: "What are they?" Not who, but "what." Their humanity is gone. Similarly, Ben (Duane Jones), the take-charge leader in *Night of the Living Dead*'s besieged farmhouse, establishes this rule: "Don't look at it!" *It.* That's a far cry from the personal, dignified naming in Genesis 1:27: "God created man in his own image, in the image of God he created him; male and female he created them."

## Draining the *Imago Dei*

For a low-budget, independent, debut feature, *Night of the Living Dead* shows surprising sophistication when it comes to the notion of the *imago Dei*. The film opens on an adult brother and sister, Johnny (Russell Streiner) and Barbra (Judith O'Dea), who have driven for hours to place a wreath on their father's grave on behalf of their mother. Annoyed at being inconvenienced, Johnny complains, "I don't even remember what the man looks like," insensitively erasing his own father's *imago Dei*. There's a certain, awful justice, then, to Johnny's reappearance near the end of the film, after he's been turned into an attacking zombie—dead-eyed, without his trademark Buddy Holly glasses to recall his former humanity.

Romero's conception of zombies as slow-moving, stumbling figures further evokes the idea of the *imago Dei* drained. *Night of the Living Dead*'s ghouls all move stiffly, torsos slightly forward, arms outstretched, as if stuck in a perpetual state of grabbing . . . grabbing . . . grabbing. In Psalm 139, King David praises God for knitting him together in his mother's womb, suggesting an intimate, individualized act of creation; when characters "turn" in a zombie movie, they even lose the idiosyncrasies of their individual gaits. And once they've been shot in the head—traditionally the only way to stop a zombie—what's left is treated with the same respect as raked leaves. "The bodies must be carried to the street and burned," a scientist urges in *Night of the Living Dead*. "They must be burned immediately. Soak them with gasoline and burn them. The bereaved will have to forgo the dubious comforts that a funeral service will give. They're just dead flesh—and dangerous!"

When we first meet the main character of *28 Days Later*, he appears to be dead flesh. Jim (Cillian Murphy) wakes up in a hospital bed, half of his head shaved and various tubes attached to his body. Both the camera angle—from a top corner of the room, where a security camera might be placed—and the medical equipment recall the chimpanzee we saw strapped to a bed in the lab of the movie's prologue. (This is the lab from which the "rage virus" emerges.) The lack of humanity in Jim's room is magnified as he wanders into the empty hallway, then out onto the streets of London, finding them in disarray and devoid of people. Director Danny Boyle and cinematographer Anthony Dod Mantle's decision to use digital cameras, which were just going mainstream at the time of the movie's release, emphasizes the hardscrabble milieu; it's as if this was the only equipment that survived in this apocalyptic setting.

Jim eventually makes his way to his parents' home, where he finds their corpses undisturbed but decaying in their bedroom. With a zombie outbreak bearing down on them and their son on life support after a bicycle accident, they chose to end their own lives by overdosing on medication, rather than succumb to the rage virus. Still held in their desiccated hands is a photo of Jim as a child—not quite when he was knit in his mother's womb, but only a few years after.

The loss of parents also plays a crucial part in *Shaun of the Dead*, a surprisingly moving entry in the zombie genre considering it's also a riotous comedy. With quick wit and comic editing, *Shaun of the Dead* lampoons the way unmotivated twentysomethings like Simon Pegg's title character sleepwalk their way through life if they don't have a sense of purpose. Amidst the cheekiness and satire, there is also this tender moment between Shaun and his stepfather (Bill Nighy), with whom he's had a contentious relationship:

"I've always loved you, Shaun, and I always thought you had it in you to do well. You just needed motivation. Someone to look up to. I thought it could be me." This comes after his stepfather has been attacked, but before he's fully turned. It took the specter of zombiehood for the man to voice the *imago Dei* in himself and to vulnerably express the potential for it in his stepson.

If *Shaun of the Dead* is about denying the *imago Dei* on a personal level, *28 Weeks Later* is about denying it on a far grander scale. This sequel to *28 Days Later* largely takes place after an American-led NATO force has wiped out the "infected" and begun resettling a quarantined section of London. Of course there's another outbreak, which the occupying military force at first tries to contain with isolation tactics, but eventually meets with a blistering, kill-them-all strategy that doesn't even bother distinguishing between "infected" and "friendlies." (In one striking image, a swarm of innocent civilians who have been locked in a room frantically bang against the doors in distinctly zombie-like fashion.) Considering *28 Weeks Later* was released in 2007, in the midst of the US occupation of Iraq, there is a potent political metaphor at work here about the way war inherently denies the *imago Dei*, and does so in mass proportions.

## Last Two Standing

The scope is decidedly smaller in *Train to Busan*, which takes place almost entirely on the transport of the title. In addition to Seok-woo, the fund manager, and his daughter, Su-an, we meet a handful of carefully drawn characters whom we come to know intimately. These include a pregnant woman named Seong-kyeong (Jung Yu-mi) and an apparently homeless man (Choi Gwi-hwa) who is

tellingly never named. As the outbreak infiltrates the train while it's en route (watchful viewers will notice that an infected victim leaps aboard as the doors close), Seok-woo's selfishness will be tested in various, *imago Dei*-related ways.

Choi Gwi-hwa's character—let's call him Gwi-hwa, borrowing the actor's name—is especially revealing. When he too snuck onto the train, with his bedraggled clothes and yellowed teeth, I at first thought he was one of the movie's zombies. (What does that say about my understanding of the *imago Dei* when it comes to those living on the streets? Gulp.) During an ill-fated stop at a train station, Seok-woo takes Su-an down a hallway he believes to be safe, but tells Gwi-hwa not to follow them. How is this insensitivity—this denial of Gwi-hwa's *imago Dei*—repaid? With a particularly Christlike gesture. When an attack breaks out at the train station and Seok-woo finds himself pinned down by a zombie, it's Gwi-hwa who throws his coat over the attacker's head as he races by, saving Seok-woo's life.

Is this what makes Gwi-hwa human, in the best sense— the willingness to risk oneself in order to sustain and protect life? In her book *The Zombie Gospel*, which concentrates on the AMC series *The Walking Dead*, Danielle Strickland suggests that a key component of our *imago Dei* is the ability to nurture. "Woven into our DNA is the capacity to create," she writes. "The first humans were caretakers of a garden. They also were intimately involved in caring for other living things, their children and the animals. Destruction is so contrary to our humanity because we are designed to create and nurture things."[1] Perhaps it's not the dead eyes or the moaning that tell us zombies have lost the *imago Dei*—it's the insatiable urge to destroy, rather than design.

This brings us back to Seong-kyeong, whose pregnancy offers another reminder of how God knit us—individually,

---

1. Strickland, *Zombie Gospel*, 58.

in the image of our Creator—in the womb. Seong-kyeong's unborn child even has a name: "Sleepy." By the time *Train to Busan* reaches its climax, only three of the passengers are still alive: Seok-woo, his daughter Su-an, and Seong-kyeong. They manage to make it to a separate train engine, only to find a zombie in the cabin. Seok-woo is bitten as he throws the zombie off the train; with horrible realization, he understands that he must now throw himself off the train as well. What is the last image that flickers on the screen before he does so? A flashback to Su-an, as an infant, in his arms.

This leaves Seong-kyeong and little Su-an as the only survivors when the engine comes to a stop at the end of the line. Before them is a long, dark tunnel, littered with smoking, damaged military equipment. At the other end, unbeknownst to them, a military sniper has their shadowy figures in his sight. Are they friend or foe? Just as the sniper is about to fire, however, Su-an begins to sing, tearfully belting out the song she couldn't perform at her school program a few days earlier because she was upset her father had not come to watch. The echoes carry down the tunnel, a distinct expression of emotion and creativity that the sniper cannot help but recognize as human—as evidence of the miracle of the *imago Dei*.

# CREATURE FEATURES

## FEAR OF NATURE RUN AMOK

Of all the beasts and creepy-crawlies that have populated so-called "creature features"—sharks, dinosaurs, alligators, ants, spiders, and whatever Godzilla is—birds distress me most.

Well, maybe not the birds in *Birdemic: Shock and Terror* or *The Birds Have Eyes III: The Crowening*, the fake film within the television series *Schitt's Creek*. It was Alfred Hitchcock (who else?) who managed to make birds truly terrifying in 1963's *The Birds*, based on a short story by Daphne Du Maurier. Maybe the avian assailants get to me in that movie precisely because they're so implausible. This makes their violence all the more shocking. I know sharks and alligators are best observed from a safe distance. Even spiders should be eyed with suspicion. But birds are harmless, right?

There's something insinuating about the way Hitchcock presents them in the movie's opening scene, set in a San Francisco bird shop. As socialite Melanie Daniels (Tippi Hedren) flirts with lawyer Mitch Brenner (Rod Taylor), who is at the shop to buy a pair of lovebirds for

his school-age sister, they do so amidst a cacophony of cages. The store is so big that it encompasses two floors; at one point Hitchcock positions the camera from high above, so that Mitch and Melanie appear overwhelmed and outnumbered. An onslaught seems inevitable.

Why do animals turn on us in these movies? Perhaps an answer can be found in Genesis. In the wake of the fall, God chastises the sneaky serpent with this pronouncement in Genesis 3:14–15: "Because you have done this, cursed are you above all livestock and all wild animals! You will crawl on your belly and you will eat dust all the days of your life. And I will put enmity between you and the woman, and between your offspring and hers; he will crush your head, and you will strike his heel." It's the "enmity" that is pertinent here. Theologians have long contended that there is christological resonance to this passage—that Jesus is the one whose heel will be struck on the cross, but who will ultimately prevail. Yet I also wonder if this is a nod to one of the results of sin having entered the world: that humans and creatures will no longer live in harmony, as intended in the garden of Eden. At times, especially in creature features, this disharmony reveals itself in monstrous ways.

## Get Out of the Water!

This is how I understand Steven Spielberg's *Jaws*. The great white shark that terrorizes Amity Island in the 1975 blockbuster is not simply feeding in the manner of an apex predator. This killer stalks its victims in "unnatural" ways. Consider the showdown that makes up the movie's final third, when Amity's sheriff (Roy Scheider), a visiting scientist (Richard Dreyfuss), and a salty seaman named Quint (Robert Shaw) ship out on Quint's boat to hunt down the great white. Before long, it's clear that they're

outmatched. The creature even seems to be toying with them. After being harpooned and hooked to three barrels—which should be impossible to pull underwater—the shark barely slows down, even diving beneath the boat as if to show off. Rather than swim away to tend to its wounds, it goes on the offensive, smashing its snout into the hull. Most people see Quint as something of a Captain Ahab figure, but it's always struck me that the great white shark is the most obsessed character in *Jaws*.

Spielberg peppers his movie with visual evidence that things in the idyllic—you could even say Edenic—beach community of Amity Island have become disordered. When the shark's first victim is discovered washed up on the sand, there is a shot of her mangled hand reaching out of a clump of seaweed, crabs skittering in and out of her open palm. The terror of an attack on a crowded beach is punctuated by a dismembered leg floating to shore. In a later shot of another victim's leg sinking to the bottom of the sea, we see a trail of blood unfurling behind it. These are all images of a good created order torn apart. When nature goes bonkers in the film, it's a fearsome reminder that all of creation, not only humanity, succumbed to the fall.

*Crawl*, a descendent of *Jaws*, considers alligators run amok. (For proof that *Jaws* is on the minds of the filmmakers, note the figurine we see on a car's dashboard early on of a shark chomping on a scuba diver.) The car belongs to Haley (Kaya Scodelario), a collegiate swimmer who ignores hurricane warnings and drives to her family's Florida home when her father (Barry Pepper) won't answer his phone. There, amidst the quickly rising waters, await massive alligators, hunting for humans with a particularly *Jaws*-like tenacity.

Even before the alligators show up in *Crawl*, directed by French fright specialist Alexandre Aja, it's the water that

represents nature unhinged. Spilling in from a lake behind the house, murky and dark, it can't be controlled. The flooding seems—from the perspective of the suburbanites who have chosen to build on this swampland, at least—out of bounds. This contrasts sharply with the water we see in the movie's clever prologue, which introduces Haley at swim practice. Here, the pool water is crystal clear, contained within a rectangular space, and carefully measured by depth and lane markers. It's even indoors. Like the shop at the start of *The Birds,* the pool is an example of humanity taking a wild natural element and corralling it on our own terms.

## Poking (or Genetically Engineering) the Bear

Another category of creature features, then, includes those in which our fear of nature unleashed is intertwined with another fear: that in trying to corral nature, we've instigated disaster. We worry, or at least these movies do, that in trying to dominate creation, we've perverted it and unleashed the very chaos now threatening us. It's the difference between *Jaws* and another Spielberg hit, *Jurassic Park*, where scientific hubris (cloning) and corporate greed (a dinosaur theme park! What could go wrong?) keep pushing the limits until a Tyrannosaurus rex ends up stomping on an SUV.

In *Jurassic Park*, the dinosaurs are the direct result of humankind's meddling. In other creature features, the monsters are side effects. Nuclear ambition births the beasts of two 1954 releases: *Them!* and *Godzilla*. In the latter, hydrogen bomb testing off the coast of Japan awakens a two-hundred-foot-tall, lizard-like behemoth that could hold a T. rex in the palm of its claw. In *Them!*, we're in the desert of New Mexico, not far from the site of the world's first atomic bomb test. The movie opens with low-angle

shots of spiky, unsettling Joshua trees standing like aliens against the sky. Nature is later depicted as an intimidating force with a dust storm, as well as frequent references by the characters to the suffocating heat. All of this suggests an inhospitable environment on the verge of monstrousness. And so when humans push the envelope by introducing radiation, it's no surprise that the results are Cadillac-sized ants with a taste for flesh.

The different attitudes these movies take toward their respective calamities is telling. Coming from Japan, where the bombs fell, *Godzilla* plays like a lament. Note the tracking shots along lines of wounded and weary citizens, obvious stand-ins for the victims in Hiroshima and Nagasaki. *Them!*, from the country that dropped those bombs, offers something closer to disassociation, if not abdication of responsibility. "If these monsters got started as result of the first atomic bomb in 1945, what about all the others that have been exploded since then?" an FBI agent (James Arness) asks at the movie's climax. The entomology expert on hand (Edmund Gwenn) offers only this: "When man entered the atomic age, he opened a door into a new world. What we eventually find in that new world nobody can predict."

In the decades since 1954, environmental anxiety has joined nuclear anxiety as one of the existential terrors of modern life. In Korean filmmaker Bong Joon-ho's 2007 film *The Host*, an American military scientist (Scott Wilson) based in Korea carelessly dumps hundreds of bottles of formaldehyde down a drain leading to the Han River. (He offers a blasé, *Them!*-like excuse to his nervous Korean assistant: "The Han is a very broad river, Mr. Kim, so let's try and be broad-minded about this.") A few years later, a bizarre creature emerges to terrorize the city.

Like Bong's 2019 Best Picture winner, *Parasite*, *The Host* is many things: broad comedy, political satire, *Godzilla* homage. But my favorite element is that creature. With a long, serpentine tail that slinks around victims, allowing the monster to carry them to its lair, this amphibious beast, about the size of a bus, can gracefully slide through the water or scamper across the ground. (That tail also allows it to swing from the underside of the expansive bridges that cross the Han River.) Multiple mandibles, meanwhile, hold endless fleshy layers and rows of jagged teeth. The CGI details may not have aged well (they rarely do), but that doesn't take away from the creature's strange beauty. All in all, it's like a cute little tadpole (or one of the canned squids we see a character eating early on) if it had been raised in Jurassic Park's labs.

## Leviathan vs. Behemoth

Similarly awesome creatures turn up in the book of Job. When God wants to remind Job of God's great power, a couple of monsters are offered as visual aids. There's something reminiscent of *The Host* and *Godzilla* in the description of the Leviathan in Job 41:12–14: "I will not fail to speak of Leviathan's limbs, its strength and its graceful form. Who can strip off its outer coat? Who can penetrate its double coat of armor? Who dares open the doors of its mouth, ringed about with fearsome teeth?" The Behemoth, as described in Job 40:16–18, could easily stand in for one of *Jurassic Park*'s marauding dinosaurs: "What strength it has in its loins, what power in the muscles of its belly! Its tail sways like a cedar; the sinews of its thighs are close-knit. Its bones are tubes of bronze, its limbs like rods of iron."

In the face of these creatures—in the face of creation— God demands humility. Something similar is demanded

of us while watching movies like *Jaws*, *Jurassic Park*, or even *Crawl*. In her book *The Face of the Deep: A Theology of Becoming*, Catherine Keller writes at length about the way the book of Job reorders our understanding of our place within creation, even as bearers of the image of God. "Christian interpreters may appreciate the sun and the stars as evidence of omnipotent order. But animals, especially wild ones, have always posed a gamy embarrassment to human dominion," Keller writes. "For nonhuman animals do all the procreating and eating that humans do; they resemble us but do not speak. In Job they break silence."[1]

In creature features, they roar. Yet if our fear while watching such movies is rooted in our inability to dominate these behemoths and leviathans, it's a faithless fear. The cultural mandate of Genesis 1:26–28, despite language like "rule over" and "subdue" in certain translations, is a charge of stewardship, not dominance and control. We are called to bring about creation's flourishing, not its submission. As Keller writes, referencing the use of "dominion" in the King James Version of Genesis, "When we mistake dominion for dominance, we fail in our responsibility as caretakers for the earth—*ipso facto* we abdicate 'dominion.'"[2] (For more on Keller's work, as filtered through the creature feature-adjacent *Alien* film series, I recommend Sarah Welch-Larson's *Becoming Alien*, which like this book is part of the Reel Spirituality Monograph Series.)

Returning to *The Birds*, are Melanie's caged lovebirds a case of mistaking dominion for dominance? Hitchcock's film stands as something of a bridge between the two types of creature features we've discussed. While there are hints that humanity may be at fault for the chaos, in the manner

1. Keller, *Face of the Deep*, 135.
2. Keller, *Face of the Deep*, 138.

of *The Host* and *Jurassic Park*, this could also be a *Jaws*-like instance of fallen nature gone berserk.

On the one hand, the movie is immediately uneasy about how birds are treated. In that shop at the start of the film, Mitch asks Melanie, "Doesn't this make you feel awful? . . . Having all these poor little innocent creatures caged up like this?" She doesn't seem to mind, considering she later buys a pair of lovebirds for Mitch's little sister Cathy (Veronica Cartwright) in a coy attempt to woo Mitch. While she's driving them out to his family's house in the seaside town of Bodega Bay, there is a comic shot of the (obviously fake) caged birds on the floor of the car, leaning from side to side in unison as Melanie careens along the swerving coastal roads. Like the fur coat she sports for the first half of the film, it's an instance of the creaturely world being bent to human whims.

Further supporting the idea that the bird assaults are part of a coordinated revenge plot—beginning with a seagull pecking at Melanie as she tries to pilot the lovebirds across the bay by rowboat—comes this bit of philosophy, offered by a local birder (Ethel Griffies) to Melanie in Bodega Bay's diner: "Birds are not aggressive creatures, miss. They bring beauty into the world. . . . It is mankind rather, who insists upon making it difficult for life to exist on this planet." A drunk at the bar (Karl Swenson) elaborates with a reference to Ezekiel: "It's the end of the world! 'Thus said the Lord God to the mountains, and the hills, and the rivers and the valleys; Behold, I, even I, shall bring a sword upon you, and I will devastate your high places.' Ezekiel, Chapter 6."

If we take the other reading, that the swarms are not acts of vengeance but simply nature gone berserk, it's still an interpretation that we should hold with humility. There is violence in *The Birds*, but the eeriest, most troubling images to me are those in which the winged creatures stoically take

up "human" space, imposing—in feathery masses—their presence on markers of civilization. This happens early on with shots of birds lined up along power lines—even more birds than usual. There's a cheeky instance of it when birds pop the balloons at a birthday party. And it's the cornerstone of the film's bravura sequence, in which Melanie sits at a bench in front of a playground, with a jungle gym behind her. Hitchcock and editor George Tomasini proceed to conduct a master class in suspense. At first, a single crow lands on the structure behind her. This is followed by a closer shot of Melanie as she lights a cigarette, without the playground in the frame. The next shot is of the jungle gym itself, now with four birds on it. Back and forth we go—from Melanie to the playground, with more birds each time—until we get a point-of-view shot from Melanie's perspective as she watches a lone crow flapping in the sky and coming to a rest on the playground, where the crows now number in the hundreds. In *The Birds*, our illusion of human dominion gets pecked away bit by terrifying bit.

Like the book of Job, *The Birds* puts humanity in our proper place. After that earthshaking, biblical monologue—leaving Job in a repentant puddle, something like Melanie, Mitch, and young Cathy quietly slinking through the yard, past rows of birds, to drive away from Bodega Bay—God offers a final word of grace. He restores and even doubles Job's fortunes (including the creatures in his herds), blesses him with sons and daughters, and lets him live to be an "old man and full of years" (Job 42:17). If Melanie and Mitch hope to have the same, perhaps they shouldn't have let Cathy bring those caged lovebirds on their escape.

# SLASHERS

## FEAR OF BEING ALONE

All Glen had to do was stay awake.

About midway through 1984's *A Nightmare on Elm Street,* Nancy (Heather Langenkamp), the teenage heroine, has things pretty much figured out. Child-killer Fred Krueger (Robert Englund) has been hunting Nancy and her friends in their dreams. If he manages to catch and kill them while they sleep, they will die in the waking world as well. Desperate after days of staying awake, Nancy asks her boyfriend Glen (a young Johnny Depp) to watch over her as she catches a bit of rest. If he sees her struggling in a dream, she tells him, he must immediately wake her up.

But Glen is tired too, so he drifts off not long after Nancy. Sure enough, in her dream, "Freddy" attacks. As in much of *A Nightmare on Elm Street,* writer-director Wes Craven merges the real world and the dream world in devious ways. Here, in the same shot, Nancy fends off Freddy and his infamous glove of knives in the dream version of her bedroom, while Glen snoozes in a corner chair in the waking world. She and Freddy even fall to the floor at Glen's feet, but the commotion doesn't rouse him.

It isn't until an alarm clock goes off, waking up both Nancy and Glen, that the spell is broken and Freddy disappears.

In the aftermath, Nancy's virulent reprimanding of the dopey Glen is one reason she's one of my favorite horror heroines: "Glen, you bastard! I just asked you to do one thing. Just stay awake and watch me and wake me up if it looked like I was having a bad dream. And what did you do, you shithead? You fell asleep!"

In the Bible, we're told about another instance of close friends falling asleep at an inopportune time, although Jesus wasn't quite as harsh in his response. After stepping away in the garden of Gethsemane and desperately praying to be relieved of the burden of the cross, he returned to find Peter, James, and John snoring. In Mark 14:37–38, he sighs, "Couldn't you keep watch for one hour? Watch and pray so that you will not fall into temptation. The spirit is willing, but the flesh is weak."

I've always been struck by the human vulnerability of Christ's loneliness in Gethsemane. In Mark 14:36, in this decisive moment, with his life on the line, Jesus pleaded, "Abba, Father . . . everything is possible for you. Take this cup from me." Yet not only did the disciples fail to provide moral support, God also offered no answer. In *When God is Silent*, Barbara Brown Taylor notes this about Christ's final days:

> From the moment he came down from the mount of the Transfiguration, the memory of God's voice was all he had left. He prayed to hear it again in the garden of Gethsemane, but the only voice he heard there was his own. He was arrested, tried, and convicted without so much as a sigh from heaven. From the cross, he pleaded for a word, any word, from the God he could no longer hear. He asked for bread and got a stone. Finally, in the most profound silence of

his life, he died, believing himself forsaken by
God.[1]

That's our deepest fear, isn't it? To be utterly alone,
without loved ones, seemingly without God. Just as our
loving earthly relationships echo the loving relationship
we yearn to have with our Creator, so too does earthly
loneliness echo the emptiness we feel when God seems far
away. Slasher films explore many fears (we'll revisit some
slashers in the "Sex and Death" chapter of this book), yet
a foundational one for the subgenre is the fear of being
alone—and the vulnerability that accompanies such
loneliness.

Consider, after all, that most of the victims in these
movies die alone. *A Nightmare on Elm Street* opens within
a dream of Nancy's friend Tina (Amanda Wyss), who
wanders by herself through a damp, industrial hallway, not
another soul to be found. (Until Freddy shows up.) The fact
that death is the end for so many of the characters in these
movies seems relevant, as well, as it uncomfortably suggests
the ultimate loneliness of the death bed.

The concept of the "final girl" applies here. First
proffered by Carol J. Clover in her 1992 book *Men, Women,
and Chainsaws: Gender in the Modern Horror Film*, the
term refers to the last survivor—almost always a virtuous
young woman—of a slasher movie. There's a reason Clover
didn't coin the phrase "final *girls*." Each survivor, from
Nancy in *Nightmare* to Adrienne King's Alice in *Friday
the 13th* to Jamie Lee Curtis's Laurie in *Halloween*, is alone
in the end, having witnessed the gruesome deaths of their
peers. In 1996's *Scream*, Wes Craven's self-referential riff
on the horror genre (the Kevin Williamson screenplay
even blatantly name-checks *A Nightmare on Elm Street* and

1. Taylor, *When God Is Silent*, 514.

*Halloween*), Drew Barrymore's Casey isn't quite the *final* girl. She's the first to go, less than ten minutes into the film. But in keeping with slasher tradition she is all by herself when Ghostface invades her home.

## Lonely Landscapes

Loneliness, vacancy, vulnerability—often in slasher flicks, the landscape itself evokes such unease. *Halloween* takes place in the suburb of Haddonfield, Illinois, which director John Carpenter depicts as a series of eerily empty, tree-lined streets. Hardly a person is seen in the film's early establishing shots of the town. Even when Curtis's Laurie heads off to school, she passes no one on the sidewalk and crosses streets without encountering a car. (There's a wry touch to the words of the song she sings to herself: "I wish I had you all alone. . . .") The final images of the movie—after masked maniac Michael Myers (Nick Castle) has murdered all of Laurie's friends—offer more emptiness: bare rooms, then back to the town's unpopulated streets. The only hint of humanity, if you can call it that, is Michael's heavy breathing on the soundtrack.

Similarly, both versions of *Candyman*—the 1992 original and the 2021 remake—emphasize the emptiness of urban blight, set as they are in neglected neighborhoods of Chicago. Directed by British filmmaker Bernard Rose, the first film both exploited and interrogated the racialized fear at the heart of this story about a hook-handed killer who haunts housing projects predominantly populated by African Americans. The remake, directed by Black filmmaker Nia DaCosta, has a firmer grasp on the lens through which it wants to tell its story. Both directors, interestingly, employ architecture to capture a sense of lonely unease: Rose via the barren, decrepit hallways of a

public housing high-rise; DaCosta by way of an abandoned tract of government-subsidized, single-story apartments, where the dark windows fill the screen like rows of lifeless eyes.

A different landscape evokes emptiness in 1974's *The Texas Chain Saw Massacre*, where the awfulness unfolds at an isolated farmstead. Part of the movie's terror—and I personally count *Texas Chain Saw* as one of the most frightening horror films ever made—comes from the fact that we cannot fully comprehend or explain the murderous, cannibal family at its heart. Yet their separation from society, something director Tobe Hooper establishes with unsettling shots of abandoned buildings in the searing Texas sun, might have something to do with it. Could some sort of sustaining community have kept Leatherface and his kin from butchering anyone who stepped onto their property? Maybe, maybe not.

There is a more personal sort of loneliness that is also at play in *The Texas Chain Saw Massacre*. Among the group of young people who unwisely stop near the farmstead after their van runs out of gas is Franklin (Paul A. Pertain), the brother of Sally (Marilyn Burns), who ends up being the film's "final girl." Franklin uses a wheelchair to get around, which frequently separates him from the rest of the group. This is especially the case when they first come across another abandoned farmhouse and the others—notably two couples—explore upstairs. Left below, Franklin angrily looks up as he hears them laughing. It won't be long before their laughing turns to screams. Franklin is lonely, certainly, and also—given his inability to move about quickly and easily—particularly vulnerable in the context of a slasher movie.

In Hitchcock's *Psycho*, you'd think the lonely figure would be Janet Leigh's Marion Crane, the woman who

fled after stealing money from her workplace, eventually stopping to hide out at the Bates Motel. The motel is certainly a lonely setting for her. As the proprietor, Norman Bates (Anthony Perkins), tells her when she checks in: "Twelve cabins, twelve vacancies." But Norman proves to be the lonely one, thanks in large part to Perkins's impeccably layered performance, one of the greats in the horror genre. Discussing the stuffed birds in the motel's office, Norman tells Marion that taxidermy is more than a hobby for him because "a hobby is meant to pass the time, not fill it." When she asks if his time is so empty, Norman stammers politely for a bit. Then one of those shadows Perkins specializes in passes over his face and Norman says, "You've never had an empty moment in your entire life, have you?"

Empty moments—those can be the scary ones. I think again of Gethsemane, when that garden must have felt, to Jesus, like a gaping void. In March 2022, a daily devotional I sometimes use, *Lectio 365*, offered this reflection on Matthew 26:36–39: "'Gethsemane' literally means 'the oil press,' which is fitting, because it is here that Jesus experiences the most intense, crushing pressure of his life: spiritually, emotionally and psychologically. Jesus begs for another way, an alternative to the terrifying death ahead. But there is none."[2] With sharp blades and piercing nails awaiting him, Christ's sense of vulnerability must have been immense.

## Wake Up!

Few of us will face that sort of defenselessness. But we are all vulnerable every time we go to sleep and relinquish complete control of what is happening around us. Even so,

2. *Lectio 365*, "Matthew 26:36–39."

sleep is seductive. We know there are times when we can't afford such weakness (hello Peter, James, John—and Glen), yet we still can't resist closing our eyes. In fact, both Glen and the disciples repeat their mistakes. After reprimanding them once in Gethsemane, Jesus goes back to pray alone. "When he came back, he again found them sleeping, because their eyes were heavy," Mark 14:40 reports. "They did not know what to say to him."

Things turn out worse for Glen near the end of *A Nightmare on Elm Street*. At this point, Nancy has decided to go on the offensive: to meet Freddy in her dreams, grab hold of him at the precise moment she has set an alarm to wake herself up, and drag him into the real world where Glen will knock him out. But as before, Glen falls asleep. In another bold stroke of grotesque surreality, the dream world and real world merge in a way so that Freddy's hand of knives lurches out of Glen's bed, grabs him around the waist, and sucks him down into a sudden hole. After a moment, a torrent of blood spews back out from the void, creating an inverse red waterfall that spreads across the ceiling of the bedroom.

Nancy, however, is a final girl, a survivor. Left utterly alone to bear her burden, she carries on, returning to sleep to face Freddy. Her elaborate plan works, as she drags him out of the dream world, where he is stymied and pummeled by a series of booby traps she has set. Her policeman father (John Saxton), who has responded to the incident at Glen's house across the street, arrives to help, but it is Nancy who ultimately vanquishes Freddy.

In Luke's account of Christ's anguished night, Jesus encounters a figure of comfort, something akin to Nancy's father. "An angel from heaven appeared to him and strengthened him," we read in Luke 22:43–44. "And being in anguish, he prayed more earnestly, and his sweat was

like drops of blood falling to the ground." Of course, in this account too, Jesus returns to find the disciples asleep. In *Nightmare*, we find a parallel in the movie's shocking and studio-imposed coda, which suggests that all of us—including Nancy—are still stuck in a terrifying dream.

In response to such unsettling, tacked-on horror endings, Scripture offers lasting comfort. For anyone rattled by a viewing of *A Nightmare on Elm Street*—or the loneliness and vulnerability stoked by any slasher movie, for that matter—might I suggest following it up with a reading of Psalm 121:3–4: "He will not let your foot slip / he who watches over you will not slumber; indeed, he who watches over Israel / will neither slumber nor sleep."

Good night. Sleep tight.

# RELIGIOUS HORROR

## FEAR OF A SPIRITUAL REALM

A peculiar music box features prominently in *The Conjuring*, a 2013 film directed by genre specialist James Wan (*Saw*, *Furious 7*, *Aquaman*). *The Conjuring* stars Patrick Wilson and Vera Farmiga as Ed and Lorraine Warren, married demonologists who work in conjunction with the Catholic Church. Shaped like a big-top circus tent, the wooden music box holds a cruddy little clown who rises and lowers as tinkling music plays. More interesting, however, is the mirror on the inside of the box's lid, which is painted with a white spiral design that slowly, hypnotically spins. Gaze into it long enough, hard enough, and you'll see . . .

Religious horror films are about revelation. Their fundamental function is to reveal to the incredulous that the spiritual realm is real. Contending with such reality can be scary stuff, no matter what your worldview. For a believer like Lorraine Warren—her face illuminated by an eerie light as she gazes into the music box's mirror—it's a reminder that the apostle Paul warned us, in Ephesians 6:12, about the "powers of this dark world." For others like

the Perron family—who seek the Warrens' help after strange happenings occur in their home, despite admitting, "We're not really a churchgoing family"—it's an undermining of the assumption that what you see in this world is all you get. When Carolyn Perron (Lili Taylor) looks into the music box early on in the film, she sees a faint, inexplicable shadow. *The Conjuring*, like much religious horror, brings shadows into the light, whether we believe in them or not.

## Closing the Music Box

In their book *The Aesthetics of Atheism: Theology and Imagination in Contemporary Culture*, Kutter Callaway and Barry Taylor cite Charles Taylor's *A Secular Age* and offer this:

> Taylor points out that, not too long ago (say, 500 years), the default assumption for most human beings was that the world was fundamentally 'porous'—constantly open (and thus vulnerable) to a host of spirits, forces, and gods that not only transcended the material world, but actively impinged upon it. This, of course, is no longer the case. Indeed, the background conditions of belief have changed quite radically for contemporary people. Along with the advent of modernity came the rise of what Taylor calls the 'buffered self,' which conceives of both the individual human person and reality as a whole as closed off from transcendence. While it is certainly true that individuals continue to exhibit various degrees of 'closed' or 'open' takes on the nature of reality, many, if not most, people (whether religious or not) now live their lives within a closed world system.[1]

1. Callaway and Taylor, *Aesthetics of Atheism*, 29.

This is, indeed, how most of us now live, which is why religious horror films play a unique cultural role. Aside from an increasing reliance on science and reason, could it also be that we've rejected a "porous," transcendent experience because it feels safer to slam the doors and shut the windows on the spiritual realm? If so, religious horror is here to once again startle us out of our complacency.

Consider *The Witch*, which takes place well before our "buffered," postmodern age. Written and directed by Robert Eggers with acute attention to historical detail, the movie follows a family in 1630s New England who leaves the safety of their settlement to set up a remote homestead alongside a foreboding forest. (The father, played by a gloomy Ralph Ineson, complains that the other settlers have drifted from a "pure and faithful dispensation of the gospels and the kingdom of God.")

If much religious horror teases us, at least for a while, about the possibility of a spiritual realm, *The Witch* wastes no such time. Less than ten minutes into the film we see a red-cloaked figure scurrying through the murky woods, having absconded with the family's newborn child. What follows is a shocking, revolting montage: a brief glimpse of a baby on a table, resting in front of a vaguely naked figure whose wizened hands pick up a knife; then that same figure, by firelight, pounding away furiously at something in a bowl; and then finally this hag, her body covered in blood, rising before a full moon. More awfulness is to come in *The Witch*, but the film's most hideous imagery appears at the very beginning, an in-your-face declaration of a dark realm.

For Eggers, it's logical to set such stories in the past, when—as Taylor suggests—it was more readily believed that spirits, forces, and gods impinged on the material world. As Eggers told the movie website *IndieWire*: "Any worldview

where everything around them is full of meaning is exciting to me, because we live in such a tiresome, lame, commercial culture now."[2]

## Scaring the Skeptics

At the same time, as postmodern audiences, we can also hold *The Witch* at arm's length precisely because it is set among religious fanatics of the 1630s. But what if a witch, or something worse, comes to call on more familiar territory—say, an irreligious single mother and her twelve-year-old daughter in 1970s Georgetown?

I have a complicated relationship with *The Exorcist*, in that I sense a disconnect between the piety of the story, based on William Peter Blatty's novel, and the exploitativeness of some of director William Friedkin's imagery. Yet I do admire the film's ironic central conceit: that it is Father Damien Karras (Jason Miller), a psychiatric counselor and priest, who is among the last to be convinced that young Regan MacNeil (Linda Blair) is actually possessed. "We'd have to get you back to the sixteenth century," Karras tells Regan's mother, Chris (Ellen Burstyn), when she asks what she needs to do to get an exorcism. Even his first encounter with Regan, in which the girl references Karras's recently deceased mother in a demonic voice, fails to convince him that something supernatural is at work.

For her part, Chris MacNeil has only come to consider an exorcism after exhausting all other options. *The Exorcist* is infamous for its pea soup projectile vomiting, but far queasier (and bloodier) are the extensive scenes of Regan undergoing medical tests and exploratory surgery. Speculative diagnoses of "chemical-electrical activity in

2. Zilko, "Robert Eggers Envies Medieval Craftsmen," lines 16–17.

the brain" and "somnambulism possession" are made by medical professionals. Even when an exorcism is discussed, one doctor takes pains to dismiss any spiritual significance: "It has worked, but not for the reasons [Catholics] think. It's purely force of suggestion." Karras might have agreed—until Regan's bed begins to levitate before him and he stares in frozen terror, paralyzed by something even more powerful than what can be seen in *The Conjuring*'s rotating mirror.

If much of *The Exorcist* plays like a debate between science and spirituality, 2005's *The Exorcism of Emily Rose* takes that debate to court. Director Scott Derrickson, who co-wrote the screenplay with Paul Harris Boardman, based the film on a 1976 legal case in Germany, transferring the setting to the rural United States. There, we follow attorney Erin Bruner (Laura Linney) as she defends Father Richard Moore (Tom Wilkinson), who has been charged with homicide following the death of a college student (Jennifer Carpenter) in the wake of a failed exorcism.

*The Exorcism of Emily Rose* is very much about evidence that a spiritual realm is real—or, at the very least, can't be denied "without a reasonable doubt." To its credit, the film keeps the audience guessing for much of its running time. Visual details that would seem to offer proof—Emily seeing a demonic face in a thundercloud or black goo dripping from a classmate's eyes—are later discounted as hallucinations, due to what could be a "psychotic epileptic disorder." And yet other elements of the film are shown from an "unbiased" perspective: the fact that Bruner's clocks stop at 3 AM, for instance, or the shadowy figure that appears in the jail cell across from Father Moore.

If forces of darkness seem to be working against Father Moore's case, it may be because of something C. S. Lewis observed in *The Screwtape Letters*, his imagined

correspondence between two demons. One of the demonic scribes offers this:

> When the humans disbelieve in our existence we lose all the pleasing results of direct terrorism and we make no magicians. On the other hand, when they believe in us, we cannot make them materialists and sceptics. At least, not yet. I have great hopes that we shall learn in due time how to emotionalise and mythologise their science to such an extent that what is, in effect, a belief in us (though not under that name) will creep in while the human mind remains closed to belief in the Enemy.[3]

In other words, they want to scare us, but not to the point that we begin to believe there is a God who can help.

## Rethinking "Religious"

To be honest, religious horror rarely scares me. Perhaps it's because, as a person of faith, my radar is tuned for that exploitative element I mentioned in regard to *The Exorcist*. Perhaps it's because, even though I'm not Roman Catholic, the language and iconography often employed strike me as comfortingly familiar, rather than strange and spooky. For that reason, I wanted to spend significant time on a religious horror movie that does disturb me, precisely because of its unfamiliarity: 1973's *Ganja & Hess*.

An avant-garde experiment from the Blaxploitation era (and remade by Spike Lee in 2015 as *Da Sweet Blood of Jesus*), *Ganja & Hess* proceeds like a fever dream, unconcerned with conventional narrative form or linear editing. The film follows anthropologist Dr. Hess Green

3. Lewis, *Screwtape Letters*, 31.

(Duane Jones, the doomed hero of *Night of the Living Dead*), who is conducting research on the ancient (and imagined for the movie) African civilization of Myrthia. When Hess is stabbed by a mentally unstable colleague with an unearthed Myrthian dagger, he develops an insatiable desire for human blood—something he tries to suppress but eventually passes on to his colleague's widow, Ganja (Marlene Clark).

Director Bill Gunn (who also appears onscreen as the murderous colleague) delivers a destabilizing stew of overlapping dialogue, image, voice-over, and music, aptly evoking Hess's woozy experience as a cursed man. As it sensually synthesizes Christian tradition with the apparently pagan practices of Myrthia, *Ganja & Hess* paints a picture of a man caught between two worlds, worlds which merge in wobbly ways. The movie is introduced by Hess's limo driver (Sam Waymon), who also happens to pastor a rousing African American church. When the pastor quotes Jesus in John 6:54—"Whoever eats my flesh and drinks my blood . . ."—the familiar language becomes disturbing, at least in the context of *Ganja & Hess*.

This tension between two spiritual realms—that of modern, Western Christianity and ancient, African occultism—can be felt in the film's very form. Frequently and without warning, the story proper is interrupted by shots of people in traditional African garb, presumably Myrthians, walking through the fields behind Hess's palatial home. Throughout the movie, African music—including, at times, a chanting piece credited as "Bungelii Work Song"— sonically merges with Western hymnody, such as 1835's "Just as I Am." (Waymon, brother to Nina Simone, also contributed to the idiosyncratic score.) And then there is a detail during the scene in which Ganja and Hess are married by his pool in a Christian ceremony. In the background,

you'll notice a woman in Myrthian apparel (Mabel King), complete with an elaborate headdress, standing amidst the crowd. With all of this washing over me, watching *Ganja & Hess* becomes a dislocating experience—similar, I imagine, to what nonbelievers might feel watching other religious horror. Something is being revealed that I don't fully understand and likely don't believe in, yet it's also something I fully feel . . . and fear.

## The Power of the Cross

The end of *Ganja & Hess* offers another point of communion between the film's two worldviews. Desperate for relief from his addiction (the movie also functions as an addiction parable), Hess reads from a pronouncement from a Myrthian queen, one that offers a possible solution to his curse. "If you worship any god whatsoever and you believe this god to be good," Hess reads, "and if this god in which you trust be destroyed by forces dangerous to the survival of love, take the implement of which this god was destroyed, for this—the symbol of the destruction of life— does cast a shadow on the heart, that he shall be released into the bosom of his creator . . ." Hess, remembering his driver, visits the church for a laying on of hands. Later, he receives his release in a dramatic scene in which he sits before the literal shadow of a wooden cross.

There is some comfort in this development, even amidst the movie's horrors (including its final moments, which return to a still-bloodthirsty Ganja). The comfort of the gospel lies not in denying religious horror and declaring that a spiritual realm doesn't exist. Nor does it lie in claiming that the only true spiritual realm contains fluffy clouds and pearly gates. No, as the apostle Paul clarifies in Ephesians 6:12, "our struggle is not against flesh and blood, but against

the rulers, against the authorities, against the powers of this dark world and against the spiritual forces of evil in the heavenly realms." And yet, in Colossians 2:15 he also testifies, alongside *Ganja & Hess*, that "having disarmed the powers and authorities, [Christ] made a public spectacle of them triumphing over them by the cross."

The shadows seen in *The Conjuring*'s spiral mirror are really there, in other words, but already defeated by the compelling power of Christ.

# SEX AND DEATH

## FEAR OF SEXUALITY

Is it possible that the Bible is more sex-positive than the horror genre?

That might sound ridiculous, given that in evangelical circles, puritanical attitudes about sex were rampant in the 1990s, amidst the alluringly sexy vampires of *Bram Stoker's Dracula* and *From Dusk Till Dawn*. But let's step away from the culture wars and return to what Scripture itself says about sex.

The words of the apostle Paul are often cited to support Christian concerns about sex, yet alongside warnings against sexual immorality you'll find something like 1 Corinthians 7:3–5, which encourages frequent (!) mutual self-giving as a crucial component to a healthy, fulfilling marriage. In the Old Testament, sexual desire is part of God's good, created order in Genesis 2:25, as well as an intoxicating blessing in Proverbs 5:18–19. And then there's the entirety of Song of Songs, which celebrates the communion of two lovers with occasionally explicit details, details that are sex-positive even if you read that book primarily as an allegory for the love shared between God and humankind.

Discussing Song of Songs in *Sex, God, and the Conservative Church*, Christian therapist Tina Schermer Sellers describes it as "one of the most ignored books in the Bible."[1] She adds,

> This text is about experiencing God's presence and essence through a passionate, awe-inspiring, and boundless love. It is an erotic message of union in which a merging of love—God's love and human love—melts into an experience of the God of Love. This is a new idea for many Christians, particularly those who have not been exposed to a Jewish understanding of the Song of Songs and who have been taught to fear sexuality, sensuality, desire, and eros.

There it is: *fear*. This fear of sexuality—rational or not, biblical or not—drives the drama in so many horror movies. Often in horror, sex equals death. Any eroticism that is experienced is swiftly, gruesomely punished, especially if the perpetrators are horny teenagers. You're likely already thinking of key titles from the 1970s and 1980s, some of which—like *Halloween*, *Friday the 13th*, and *A Nightmare on Elm Street*—I've already mentioned in previous chapters. Yet before we revisit that era, let's go all the way back to 1942 and *Cat People*.

## Meow!

Directed by Jacques Tourneur under the auspices of famed horror producer Val Lewton, *Cat People* slinks across the screen, curling amidst shadows and shadowy desires. Simone Simon plays Irena, a Serbian immigrant to New York City who falls for marine architect Oliver Reed (Kent

1. Sellers, *Sex, God, and the Conservative Church*, 72.

Smith). Though Irena has sexual urges (she brazenly invites Oliver into her apartment alone on the afternoon of their first meeting), she fears following through on them. Even after they marry, she begs Oliver to have patience, worried that consummation would release the "evil inside me." Separate beds it is.

What evil is Irena referring to? While undergoing analysis with Dr. Louis Judd (Tom Conway), Irena says she suffers from a curse of her home country, that of "cat women . . . women who in jealousy or anger or out of their own corrupt passions, can change into great cats like panthers." Judd, the doctor, puts a more existential spin on the situation: "There is, in some cases, a psychic need to loose evil upon the world. And we all of us carry within us a desire for death. You fear the panther, yet you're drawn to him, again and again. Could you not turn to him as an instrument of death?"

While making her confession to Judd, Irena rests on a couch in his office, inky blackness all around except for an oval of light on her face. Earlier, during that afternoon date in her apartment, the room grows darker and darker as the sun fades, Irena and Oliver's figures becoming silky silhouettes. The movie's signature sequence—when Irena, in panther form, stalks a romantic rival while she goes for a night swim at an indoor pool—is a nearly abstract display of shadows and reflections. And during a nighttime confrontation between Oliver and Irena at his office, where the underlit drawing tables emit a soft glow, Oliver holds a drafting tool up as a weapon, causing a shadowy cross to form on the wall behind him. "In the name of God," he pleads, "leave us in peace." Throughout *Cat People*, sex and death take place in the shadows. Characters only survive if they stay in the pure white light.

Paul Schrader is not a filmmaker who deals in black and white, so it's no surprise that his 1982 remake of *Cat People* is a bit . . . smudgier. Here, Nastassja Kinski plays Irena, who falls for a zoo curator (John Heard) while simultaneously being incestuously pursued by her brother Paul (Malcolm McDowell). The fact that Paul is also a pastor jibes with Schrader's penchant for religious provocation. His films often equate sex not only with death, but also transcendence (perhaps most explicitly in *First Reformed)*. In *Cat People*, that pendulum swings back and forth, but eventually comes to rest on the mortal side of things. When Irena tells Paul that her desire for the zookeeper is an expression of love, Paul hisses back, "It's blood. Death."

## Naughty, Naughty . . .

If Schrader interrogates his own tortured desires with *Cat People* (the preacher is named Paul, after all), the two most notorious sex-and-death pictures implicate their audiences. Both 1978's *Halloween* and 1980's *Friday the 13th* open with extended suspense sequences from their respective killers' points of view, then proceed to align the audience with the puritanical monsters throughout the movies' running times.

By far the weaker of the two (and clearly the copycat), *Friday the 13th* begins with a 1958 prologue at a lakeside summer camp. As a group of counselors sing the vaguely spiritual camp staple "Michael," with its "hallelujah" refrain, two of them share knowing glances, then sneak off to a quiet shed. (This makes them not only irresponsible, but possibly sacrilegious.) From the killer's point of view, with the camera peeking around a corner, we see their legs entwined and hear panting on the soundtrack. When the attacks ensue, it's as if *we're* the perpetrators; the sequence

ends with a freeze frame of the woman screaming directly into the camera.

Much later, after the film has jumped ahead to the 1970s and a new group of counselors have been tediously dispatched by this same killer, we learn that the attacker is none other than Mrs. Voorhees (Betsy Palmer), whose young son died at the camp decades earlier. "The counselors weren't paying attention," she shrieks. "They were making love while the young boy drowned!" In Mrs. Voorhees's mind, the cycle has only continued with this new batch of frisky young people.

The movie seems to agree. On the drive to the camp, one of the counselors (Jeannine Taylor) massages her boyfriend's bare shoulder as he moans. Later, that boyfriend (Kevin Bacon) sports a skimpy swimsuit that's ridiculously stretched beyond its capabilities. At one point a game of "strip Monopoly" breaks out. There's not a lot of actual sex in *Friday the 13th*, but Mrs. Voorhees knows what's on the minds of these counselors.

In *Halloween*'s prologue, it's the killer's sister who must pay for her sins. At the tender age of six, Michael Myers (Will Sandin) watches through the window as his older sister Judith (Sandy Johnson) makes out with her boyfriend (David Kyle) on the couch, then leads him upstairs. Little Michael dons a clown mask—our first-person point of view briefly obscured as it covers the camera—and goes in for the kill.

Fifteen years later, Michael has escaped from incarceration and returned to his home town to wreak more havoc. *Halloween* isn't so much about Michael Myers, unstoppable punisher of sexual sin, as it is about the sexual anxiety of teenager Laurie Strode (Jamie Lee Curtis). Left babysitting while her friends scheme to get together with their boyfriends, Laurie is both jealous and disapproving. Curtis, in her feature debut, gives a layered performance,

suggesting the complicated experience of missing out on something you aren't even certain you really want. When Laurie, while babysitting, dons a matronly apron to carve a pumpkin, she seems perfectly content—as if she found a way to skip physical intimacy altogether and go straight to being an asexual middle-aged mom.

As for Myers, he's most compelling as a metaphorical manifestation of Laurie Strode's sexual fears. This fits with the way director John Carpenter and cinematographer Dean Cundey portray him: as a metaphysical presence who may only exist in her head. When he arrives in Haddonfield and begins stalking Laurie, Michael often stands in broad daylight, wearing an awful, ostentatious mask (famously, a modified mask of William Shatner as *Star Trek*'s Captain Kirk). It's as if he doesn't care if others see him—or perhaps he knows that, as a projection of her fears, only Laurie can. During the climactic showdown between Michael and Laurie, she stands terrified against a wall as the mask imperceptibly emerges from the darkened doorway next to her. It's a horrifying image of the stalking, sexually ambivalent subconscious.

## Intertwined

Sexuality also has a metaphysical presence in 2015's *It Follows*, a film that nods to *Halloween* with its barren suburban streets and synthesizer score. The main character is Jay (Maika Monroe), a young woman who discovers, after having sex with her new boyfriend, that he has passed a curse on to her. He tells her to look out for a slowly approaching figure—which changes in appearance and will sometimes look like someone she knows—because if it catches her, it will kill her. The only way for her to escape the curse is to have sex with someone else.

*It Follows* proceeds with a heavy sense of dread, something writer-director David Robert Mitchell emphasizes with shots that slowly pan 360 degrees, reminding us that this strange threat could come from anywhere. Many interpreted the film as a metaphor for sexually transmitted diseases, but there's a more spiritual reading as well. By allowing its characters to live in the aftermath of their sexual activity and wrestle with the implications of it—instead of offing them in the midst of it, as in *Friday the 13th*—the movie gives sexual activity a metaphysical weight. Rather than depicting sex as titillatingly naughty, frivolous, or simply an inconsequential physical act among consenting adults, *It Follows* recognizes sexuality's significance to us as created beings in search of meaningful connection.

If *It Follows* tweaks the sex-as-death dynamic, 2022's *X* tries to invert it. Written and directed by horror specialist Ti West, the movie follows a band of free-spirited young people who have rented a cabin on a desolate patch of Texas property owned by an older couple. Unbeknownst to the couple, their guests plan to shoot a quickie porn film. When that comes to light, things don't go well.

West, a student of horror, clearly means to riff on *The Texas Chain Saw Massacre*, but *X* is more interesting for the ways it intends to be a liberating, hedonistic riff on the sex-as-death subgenre. The killers this time are motivated not by a deranged sense of morality, but jealousy. No longer able to enjoy sex themselves because of the husband's ailing heart, the couple is driven to gruesome acts when their loss is shoved in their faces by these frolicking interlopers.

West confuses things by casting Mia Goth in a dual role: as one of the youthful porn actresses and as Pearl, the farmer's wife, under grotesque makeup and prosthetics. Are we supposed to sympathize with her and honor her desires

or be disgusted by the thought of an aged, sexual woman committing atrocities? The movie wants to have it both ways. Still, what's clear is that *X* sees sex in a purely positive light, unlike a hypocritical effort like *Friday the 13th*. And yet it also undersells our value and agency as sexual beings. As the other actress appearing in the porn film (Brittany Snow) declares: "It's just sex. You can decide who you want to love, but not who you want to screw. Attraction is out of our control."

Such definitions put a cap on what the sexual experience can be. In fact, they recall an early, quiet moment in *It Follows*, which takes place after Jay's sexual encounter with her boyfriend (Jake Weary), but before she learns of the curse. Stretching out in the back seat of his car, she reminisces about how she and her friends used to dream about being old enough to drive and go wherever they wanted. "Now that we're old enough, where the hell do we go?" she asks. She might as well be talking about her sexual experiences. She can now have sex whenever, with whomever, but where have those experiences taken her?

*X* might answer that it doesn't matter—that it's the fleeting moment of experience itself that counts. Scripture, however, suggests our sexual experiences do follow us. In *Sex, God, and the Conservative Church*, Schermer Sellers writes, "The body, the spirit, and sexuality become inextricably woven together, a tapestry of God-given humanness that cannot be unraveled or ripped apart without damaging the whole artwork that is the integrated human self."[2] Sex is not something naughty, then, as the likes of *Friday the 13th* would have it, but a potent force, as *It Follows* demonstrates. It's a gift we should treasure and hold tenderly, rather than fear.

2. Sellers, *Sex, God, and the Conservative Church*, 72.

# FOUND FOOTAGE

## FEAR OF THE DARK

What's more frightening in a found footage horror movie: what we can't see, or what we can?

This is the central tension of the genre, in which what appears onscreen purports to be real-world footage, found in the aftermath of some horrible event and presented without adornment or explanation. The characters—the ones who hold the camera—are the de facto directors, choosing what we see and what we don't. Late in *The Blair Witch Project*, one of the film students being tormented by unseen forces in the Maryland woods turns the camera on herself, frantically glances toward the top left corner of the screen, and whispers, "I'm scared to close my eyes. I'm scared to open them." Exactly.

Conceived and co-directed by Daniel Myrick and Eduardo Sanchez, *The Blair Witch Project* shook the 1999 Sundance Film Festival. The film's promotional strategy convinced some audiences that what they were watching— supposedly footage that was recovered after three students went missing while making a documentary on a local legend about a witch—was real. That's a testament to the rigorous

attention to form on the part of Myrick and Sanchez (who offer a mixture of color video and black-and-white, sixteen-millimeter cinematography), as well as to the naturalistic performances by Heather Donahue, Joshua Leonard, and Michael C. Williams (whose characters share their first names in another gesture of verisimilitude). Unlike any horror film before it, *The Blair Witch Project* felt "real."

It also launched a renaissance of the found footage technique for horror purposes. These movies—their amateur aesthetics only bolstering the illusion of reality—unnerved audiences in a unique way. Most fright flicks exploit our instinctual fear of the dark, but found footage films heighten that fear to existential, even spiritual, proportions. They tease us with images that claim to show what "actually happened," yet even those images—often out of focus or seen from canted angles or cut off abruptly—fail to capture the full picture. Left in this "darkness," our imaginations run wild, reaching for any sort of assurance.

What we're seeking, ultimately, is full knowledge—something akin to the omniscience of God. "Great is our Lord, and abundant in power; his understanding is beyond measure," the psalmist writes in Psalm 147. We're told in Hebrews 4:13, "Nothing in all creation is hidden from God's sight. Everything is uncovered and laid bare before the eyes of him to whom we must give account." Can't our cameras provide this sort of knowing, one that answers our questions, calms our fears, and re-establishes a rightly ordered world? That's the promise of the found footage horror film. The terror comes when the cameras fail us and we're plunged, like mortal beings, back into the disordered dark.

## Desperate to See

In *The Blair Witch Project*, Heather clings to her camera even before the group begins hearing strange things in the night. Her recordings of piles of rocks and burbling streams are for the documentary, but she also collects these images to better understand the world around her. When the nighttime harassment begins—clattering, clacking noises in the distance, the small voices of children a bit closer, then hands beating against the tent (my cackling older cousins from childhood should have gotten a story credit)—this "need to see" becomes even more pressing. Often left in the literal dark, Heather, Josh, and Mike depend on the light of their cameras to reveal the source of their terror.

This is also true of the camera set up in a young couple's bedroom in *Paranormal Activity*. After weeks of unexplained bumps in the night, Micah (Micah Sloat) convinces Katie (Katie Featherston) that they should position a camera to record themselves while they sleep, as well as the hallway outside the open door of their bedroom. And so much of the 2007 movie, written and directed by Oren Peli, consists of a single specific shot from a home video camera, with a time counter running at the bottom corner of the screen, its flicking numbers heightening the tension.

I don't know if I've ever scoured a movie as intensely as I scour these static shots in *Paranormal Activity*, waiting for some audiovisual answer to emerge from the overnight dimness. With a diabolically clever sense of patience, Peli drips out the revelations slowly, over the course of many nights. One recording reveals lights turning on in the hall; another shows the bedroom door mysteriously closing. In a particularly creepy video, Katie gets up and stands by the side of the bed in a trance for two hours. Every time I revisit

the film I watch these moments trying not to blink, for fear of missing something.

Katie doesn't think the recordings are helping—"Maybe we shouldn't have the camera," she suggests—but Micah feels empowered. Indeed, on the first night they have the camera, he plays the part of director, experimenting with angles and lighting schemes to create the best "shot." They both eventually learn, however, that such technology has its limits. There is a terrifying moment where an unseen force drags Katie from her bed and down the hall, into the darkness. The camera remains fixed on its tripod, unable to peer into the void where she vanished. A few days later, in shock from the attack, Katie screams the truth to Micah about his surveillance: "You are powerless!"

## Lost in the Dark

In *REC*, a 2007 Spanish-language film co-directed by Jaume Balagueró and Paco Plaza, the camera tries to speak truth *to* power. The movie follows television reporter Angela Vidal (Manuela Velasco) and her cameraman, Pablo (Pablo Roso), on assignment as they accompany paramedics on a distress call to a Barcelona apartment complex. When things horribly escalate after a raving older woman severely bites a police officer, the authorities outside barricade everyone in the building, claiming a health emergency but providing no other information. Fearful and enraged, Angela tells Pablo to keep recording. "We have to show what's happening," she insists, believing she'll eventually get out of the building and deliver an exposé on the decision to keep them contained.

Unfortunately, Angela doesn't yet realize she's in a zombie movie. Here, too, the camera can only see and do so much. This is especially true of the film's climax, when Angela gets trapped, without lights, in the building's

penthouse, where a ravenous creature clatters about trying to find her. Angela turns on the camera's night vision setting but drops the camera while scrambling to escape. Her screaming face as she's yanked away is the only thing the camera reveals.

Neither of the two cameras employed by the student filmmakers in *The Blair Witch Project* has a night vision feature. Not that one would help. The forest surrounding them is too deep and vast. Just as Peli used formal limitations to his advantage in *Paranormal Activity*—creating suspense over what's happening just outside of the fixed frame—so do Myrick and Sanchez create a horror movie out of what is missing. Some scenes take place in total darkness so that the audio from Heather's video camera provides our only sensory clues. Others unfold under the sparse light of the video camera's lamp, which is just strong enough to illuminate the spindly branches that are three feet in front of us, not the horrors that lay beyond. In the movie's stunning climax, it's not Heather and Mike whom we see falling prey to the Blair Witch (or whatever it is that is hunting them), but their cameras, as one, then the other, crashes to the ground, delivering a canted view of the dirt and nothing else.

A similar shot appears in 2014's *As Above, So Below*, which follows an illegal expedition into the catacombs beneath Paris. The characters here boast a battery of cameras, as each wears one alongside a headlamp while plunging from one tunnel to another. In search of the mythical "philosopher's stone," these explorers find things far more horrifying instead. At one point, while fleeing from mummified monsters, they drop one of the cameras. From its point of view, we can see their figures scurrying down a corridor, the darkness encroaching upon us as their headlamps get farther and farther away.

## Reaching for the Light

At another point in *As Above, So Below*, the darkness is welcomed. Standing in a tomb where they appear to be trapped, the archaeologist leading the expedition (Perdita Weeks) tells everyone to turn off their headlamps. We're plunged into blackness, but then we see it: a flickering light, beneath the water of a pool at the edge of the room. It's a way out, but it took the darkness to find it.

What other lights can be found in darkness, even the darkness of found footage horror? Perhaps we need to expand our understanding of the genre for an answer. In the 2010s, in the wake of the found footage revival, horror "movies" played routinely on social media feeds. These consisted of mobile phone images of unarmed (and mostly African American) citizens being killed by police. In their graphic, lethal, real-as-it-gets nature, these recordings disturbed more than any monster movie or slasher film. They allowed us to "see" things that had previously been kept in the dark.

In this sense, something like 2017's *Whose Streets?* could be considered a found footage horror film—one that, like *As Above, So Below*, captures both darkness and flickers of light. Directed by Sabaah Folayan and Damon Davis, the documentary examines the aftermath of the 2014 killing of Michael Brown by police officer Darren Wilson in Ferguson, Missouri. Along with talking head interviews, the film contains scores of mobile phone videos, some taken during the hours Brown's body was inexplicably left on the street and others from the ensuing days and nights of protests.

On one chilling recording taken during the unrest, residents standing behind a chain-link fence are told by law enforcement officials via loudspeaker to return to their

homes. When one of them shouts, "This is my backyard!" they're fired upon with gas canisters, smoke enveloping the screen. In the documentary's immediate, visceral images, we experience the massive military presence (dogs, trucks, weapons) that was unleashed on Ferguson's citizens.

Writing for *Think Christian* in 2015, Kimberly Davis described the use of camera phones to document such scenes as a "measure of justice. . . . It is about the knowing. It is about seeing with our own eyes, if we can stand to look at it."[1] There is a cumulative, illuminating truth to the images we see in *Whose Streets?*, a way for us to experience how a neighborhood was turned, in the words of one activist, into an "unseen war." The documentary looks around the dark tomb of racial violence and institutionalized indifference, a tomb even darker than the space found in *As Above, So Below*, and shines a hopeful light. It makes room both for Christ's righteous anger—the kind we see when he disrupted the marketplace in Matthew 21:12–13—and his unfailing love (the latter of which is embodied in a video of onlookers who gather the wailing mother of Michael Brown into their arms).

*Whose Streets?* aches for the world to be rightly ordered. *As Above, So Below* concludes with a clever camera trick that depicts something akin to this, albeit in a very different context. After fleeing from monsters and ghouls by traveling farther and farther down into the catacombs, the three remaining survivors of the expedition find what appears to be the underside of a manhole cover—only it's on the floor. Sliding it open and looking down into it, they are astonished to see the night sky. A camera and headlamp is tossed into the hole. Or "up," as the case may be, considering the film cuts to an upside-down image of a Parisian street, where the camera lands. After the explorers

1. Davis, "New Technology of Social Justice," lines 11, 36–39.

climb out (from top to bottom of the screen), one of them grabs the camera and inverts it, so that the streetscape appears "right side up." It's still dark out, but finally these tormented souls can see things the way they're meant to be.

# BODY HORROR

## FEAR OF THIS MORTAL COIL

I bite my fingernails. Always have. It's gross.

I was made keenly aware of this while watching *The Fly*, director David Cronenberg's 1986 remake of the 1958 B movie of the same name. Scientist Seth Brundle (Jeff Goldblum) invents a successful teleportation device, although an early test session goes askew. While he is attempting to zap himself from one "telepod" to another, a fly sneaks into the pod with him. Brundle comes out the other side with the insect's DNA embedded in his, causing his body to undergo disturbing changes. Among the first? His fingernails peel off at the slightest touch.

As body horror goes, that's a fairly innocuous image (believe me, far more disturbing descriptions are ahead). Whether quietly unnerving or explicitly disgusting, these movies recognize that our bodies are strange things and that we have strange relationships to them. Such films are often about what happens when the bathroom door is closed—and locked. Why do I still bite my fingernails, sometimes to the point of making them bleed? Such a nasty habit suggests that the boundary between our physiology

and our psychology is a permeable one. And I'd say the same—contra the gnostics of early church history—about the physiological-spiritual divide.

Christianity resonates for me, in part, because it's a bodily religion. In the beginning, God chose to create us as corporeal beings, declaring the results in Genesis 1:31 as "very good." In Psalm 139:14, David proclaims, "I praise you because I am fearfully and wonderfully made . . ." And in Romans 12:1, Paul encourages us to offer our bodies as "a living sacrifice, holy and pleasing to God." All of this culminates in the incarnation of Jesus Christ. As Ronald J. Feenstra wrote in *The Banner*, "Christ did not assume our flesh once, only to abandon it after his death. Rather, through his bodily resurrection he both affirms the goodness of the original creation, including our bodies, and points to a future in which we enjoy the goodness of embodied life as God intended it."[1]

Conversely, a biblical view holds that the breakdown of the body—via illness, desecration, death—goes against God's design. Decay and death are both the first enemy, in Genesis 3, and the last, as described in 1 Corinthians 15:26. And so our fear of mortality—of "this mortal coil," as Hamlet would describe it—is both a physical and a spiritual one.

## Be Afraid, Be Very Afraid

*The Fly* ranks among the most palpable cinematic renderings of this fear that I've seen. Interestingly, the film offers a creational framework, tracing—much like *Frankenstein*—a scientist's disastrous attempt to mimic our Creator God. Consider the telepods: although dark and coldly metallic

1. Feenstra, "Resurrection of the Body," lines 30–33.

on the outside, inside they glow with a white-hot sheen and emit a primordial mist. When Brundle punches his code into the computer, activating the devices, he might as well command, as God does in Genesis 1:3, "Let there be light." This would-be Eden 2.0 is ruined, however, not by a serpent, but a fly. The result? Creation awry.

At first, unaware of the fly's involvement, Brundle believes his increased strength and energy mean that the teleportation process has "purified" him and enabled him to reach his true "potential." This leads to Brundle's unhinged diatribe, delivered by Goldblum with his characteristic, oddball enthusiasm. "You're afraid to dive into the plasma pool, aren't you?" he asks Geena Davis's Ronnie, a science journalist with whom he's become romantically involved. "You're afraid to be destroyed and recreated, aren't you?"

But what Brundle has experienced is dis-creation, not re-creation. And Ronnie knows it, beginning with the coarse, spiky hairs she notices sprouting from Brundle's back. When he fails to convince Ronnie to try the teleportation device, he brings another woman to his lab for that purpose. Ronnie warns her, "Be afraid. Be very afraid."

Eventually, as the fly's DNA takes over—causing Brundle's now-unnecessary ears to fall off and his teeth to drop out—the scientist becomes fearful too. In its depiction of this bodily decay, *The Fly* recognizes something similar to what Paul describes in Romans 5:14, the reality that "death reigned from the time of Adam . . ." As his condition worsens, Brundle asks Ronnie, "What's happening to me? Am I dying? Is this how it starts? Am I dying?" Later he describes his predicament as a "bizarre form of cancer." Released in the early stages of the AIDS epidemic, *The Fly* represented, for many critics, the physical ravages of that awful disease.

## Appetites of . . . and for the Flesh

Notably, not all of Cronenberg's body horror pictures depict transmogrification and the attendant physical pain as a regrettable symptom of original sin. In other films—those that came both before and after *The Fly*—bodily suffering brings enlightenment, even pleasure. In 1983's *Videodrome* a VHS tape throbs like a beating heart and characters exalt the "new flesh." *Crash*, released in 1996, follows a film producer who survives a car accident and becomes involved with people who are aroused by automobile wrecks. In 1999's *eXistenZ*, people insert ports into their spines in order to play advanced virtual reality games. And in *Crimes of the Future*, from 2022, operations are conducted as art performances, leading one character to observe that "surgery is the new sex." In each of these films, technology also plays a part in blurring the line between pain and pleasure.

Movies like these suggest that one way to deal with our fear of our mortal bodies is to deny that we should be afraid of physical affliction—indeed, to claim that it might be desirable. This notion is taken to its sadomasochistic extreme in 1987's *Hellraiser*, written and directed by Clive Barker (a novelist whose work also provided the source material for *Candyman*). After opening a mysterious box that promises untold pleasures, hedonist Frank Cotton (Sean Chapman) pays a hefty price: bizarre, leather-clad beings from another dimension—led by a needle-bedecked bogeyman who came to be known colloquially as Pinhead—rip Frank's flesh apart with hooks and chains. Frank can only become whole again by bathing in the blood of others, something his lover Julia (Clare Higgins) enables by luring men into her home and then murdering them. The sight of Frank slowly emerging from a pile of viscera in the wake

of each killing feels like a demonic variation on Ezekiel 37, where the prophet watched as "dry bones . . . came together, bone to bone [and] tendons and flesh appeared on them and skin covered them." If that imagery was meant as a prophetic vision of a restored Israel, Frank the Monster (as actor Oliver Smith is credited in these scenes) offers a vile counterpoint.

*Hellraiser* spends a lot of time arguing for pain as pleasure (the flashback sex scenes between Frank and Julie have a tinge of violence). But I can't say that Pinhead (Doug Bradley) and his cronies make for convincing sales-creatures. *Raw*, a 2017 film from French writer-director Julia Ducournau, offers a more relatable understanding of dangerous desire—even if its premise is also outlandish. The film centers on Justine (Garance Marillier), a teen who moves into a dormitory to begin her veterinary studies. As part of an initiation rite, the vegetarian Justine is goaded by older students into eating a raw rabbit kidney. Not long after, all sorts of meat begins to look good to her.

This includes, in the movie's most jarring scene, a classmate's finger, which has accidentally been cut off in a scissors accident. As the classmate lies on the ground, passed out from shock, Justine regards the bloody digit with fascination . . . then takes a bite. (Ducournau punctuates the moment with a blackly comic music drop.) If that sounds revolting (and it is), *Raw* interweaves such sights with other images of insatiability that we can better understand, especially if we recall the wide world of desires that seemingly open up to us in our youth. Justine's dormitory, apparently devoid of adult supervision, is the setting for nonstop partying among the students, with basement raves, copious drinking, and indiscriminate hookups. As Justine's growing appetite parallels the appetites of those around her, *Raw* offers a reflection on our ravenous human nature and

how difficult it can be to control. Here, it's our vitality, not our mortality, that we should fear.

## Psychosomatic Body Horror

In *Raw*, the body horror is literally realized; when Justine nibbles at that finger, she's actually doing it, not imagining it. Two giants in this genre work on a more metaphorical level: *Eraserhead* and *Tetsuo: The Iron Man*. Consider them psychosomatic body horror.

*Eraserhead*, the 1977 feature debut of dream-weaver David Lynch, could be read as a nightmare about the prospect of having children. The movie centers on a new father (Jack Nance) whose mewling baby resembles an in utero ET. Stranded in his one-bedroom apartment, where a constant, buggy buzz hisses from the radiator, the man stares with horror at the monstrosity on his dresser—a revolting creature, even before strange pustules form on its face. The fact that the father may be dreaming all of this doesn't make the body horror elements—including a moment in which his head pops off and the worm baby emerges from his gaping neck—any easier to digest.

Likewise, 1989's *Tetsuo*—which is indebted to *Eraserhead* for both its industrial setting and insidious sound design—could also be taking place in its main character's head. Tomorowo Taguchi plays an unnamed Japanese man who hits someone with his car, then dumps the body in the woods. Bizarre dreams follow, in which the hit-and-run victim (played by writer-director-editor-effects artist Shinya Tsukamoto) appears as a mechanical demon of sorts, with grease covering his body and molten lead lining his face. Soon the driver begins mirroring this physiology, starting with metal hairs on his face that spurt blood when he shaves. "I'm being punished, that must

be it," he desperately surmises as wires and coils slowly envelop him. If such body horror is imagined on the part of the characters in both *Tetsuo* and *Eraserhead*, the fears they represent—of fatherhood, of guilt—are all too real.

## Surrendered Unto Death

*The Fly*, as I mentioned, can stand in for many fears: of cancer, of AIDS, of nature run amok, and of our capacity to sin (to cite two earlier chapters in this book). Yet as Brundle's condition deteriorates, the movie's foundational fear comes into focus: death. Eventually, Brundle becomes something his computer analyzes as "Brundlefly," a giant, walking, humanoid insect, envisioned with fleshy limbs and bulbous eyes by legendary special effects artist Chris Walas (*Raiders of the Lost Ark*, *Gremlins*). Brundle admits to Ronnie that he was wrong and asks for her help, but it's too late. His body has failed him, as all of ours eventually will.

What hope is there, then? Not in Brundlefly, certainly, nor in the futuristic fusion of flesh and technology that other Cronenberg pictures depict. (And I say that as someone who has titanium in his body as part of a replacement hip.) Rather, our hope lies in a core claim of the Christian faith: the resurrection of the body. In Romans 8:11, a few chapters after Paul traced death back to Adam, he writes of the bodily implications of Christ conquering death by rising from the grave: "And if the Spirit of him who raised Jesus from the dead is living in you, he who raised Christ from the dead will also give life to your mortal bodies because of his Spirit who lives in you."

What will this look like? In 1 Corinthians 15:42–44, Paul likens our current bodies to seeds. "The body that is sown is perishable, it is raised imperishable; it is sown

in dishonor, it is raised in glory; it is sown in weakness, it is raised in power; it is sown a natural body, it is raised a spiritual body." In that *Banner* article cited earlier, Feenstra imagines it this way:

> We are like acorns that will grow into oaks at the final resurrection. Although our resurrected bodies will be glorious beyond anything we have yet seen, still they will be rooted in the bodies we have now. Our human anatomy, with its marvels and intricate design, gives just a glimpse into the glory to come. Moreover, our constant fight against disease, decline, and death in this life will give way to embodied life with God and with others that will suffer no decay or destruction.[2]

No nail biting either, I like to think.

2. Feenstra, "Resurrection of the Body," lines 36–41.

# PROPHETIC HORROR

## FEAR OF SOCIETAL EVIL

*U*s, a 2019 film from writer-director Jordan Peele, has many curious elements, some of which may not make sense until after the movie is over. Foremost among these is an early moment where Red, a creepy, jumpsuit-clad mystery woman who has invaded a family's vacation home and taken the family hostage, is asked by the terrified father, "What are you people?" Red's croaking reply: "We're Americans."

Red's answer makes little sense in the moment. But it eventually clicks, especially if you see the film in prophetic terms. That's easy to do, considering its frequent references to Jeremiah 11:11. (Peele's *Nope*, released in 2022 as this book was being completed, begins by quoting Nahum 3:6, but that intricate movie deserves to be dissected in a tome of its own.) As *Us* unfolds, the movie delivers a prophetic wake-up call about rampant American consumerism and the exploitative economics that enable it. It speaks to our fear that greed is getting the better of us.

In *Five Views on the Church and Politics*, Bruce L. Fields contributes a chapter entitled "The Black Church

(Prophetic) View." There, Fields discusses four distinct qualities of prophetic witness: it comforts those who are oppressed (by societal evil in particular); it exposes evil, speaking truth to power; it demands correction, a turning away from evil; and it affirms God's people in their efforts to seek justice.[1] Prophetic horror films exhibit two of those qualities: they unmask societal evil and demand a turning away from it—a demand that is made not only of their characters, but also of their audiences.

In the Old Testament, societal evil was often characterized as a form of idolatry. Sometimes these were literal artifacts, such as the "wooden idol" that the prophet Hosea condemned in Hosea 4:12, alongside a host of idolatrous practices that the Israelites were engaged in. Sometimes the idols were ideas, such as greed (Amos 8) and warmongering (Mic 3). In all cases, the prophets preached against practices that placed some worldly wish above love of God and neighbor.

## We the Greedy

Prophetic horror films, then, also identify idols. Consider the affluence on display in *Us*. The vacationing family has a second home, a nice car, and a new boat; when they meet friends at the beach, the fathers' conversation is a passive-aggressive game of "keeping up with the Joneses," with little digs about whose boat is better. Jump ahead to later that night, when the family members (Lupita Nyong'o and Winston Duke as the parents; Shahadi Wright Joseph and Evan Alex as the kids) are getting ready for bed and Red shows up with a "family" of her own. (Indeed, this mother, father, daughter, and son are played by the same

1. Fields, "Black Church (Prophetic) View," 97.

actors.) Having subdued the homeowners, Red sits before them by the fireplace and tells a wild tale: she and the other doppelgangers were created in underground labs decades ago, designed by unnamed conspirators to control their aboveground counterparts like puppets. When the experiment failed, the "shadows" were abandoned, left to survive far below the earth on nothing but the white lab rabbits that were also being kept in cages. Having escaped, Red believes that she can only claim the affluent life she missed out on by murdering the person who had been enjoying it in her place.

As the two mothers, Red and Adelaide, Nyong'o delivers a powerhouse double performance—one of the best in the horror genre. She gives the former the disjointed gait of an injured ballerina and the latter the ferocity and focus of a mother bear. Looking into Red's wide eyes while shackled to her own coffee table, Adelaide sheds a stream of silent tears, something Red eerily matches with her own droplets. These close-ups recall not only Peele's first film, *Get Out*, in which another immobilized character (Daniel Kaluuya) wetly expresses terror, but also the fact that the Old Testament figure Jeremiah is known as the "weeping prophet" because of the emotional tenor of his proclamations.

More literal references to Jeremiah are littered throughout *Us*, particularly to Jeremiah 11:11, in which the prophet predicts God's judgment on the nation of Judah for its idolatrous ways. ("Therefore this is what the Lord says," the verse reads. "'I will bring on them a disaster they cannot escape. Although they cry out to me, I will not listen to them.'") In the opening scene, set at a carnival, a skeevy man holds a sign that reads "Jeremiah 11:11." On the night of the attack, we hear the score of a baseball game the father is watching announced as "11–11." That's also the time

79

on the clock in the family's home just before Red and the doppelgangers invade.

Given these references and Red's tale of woe, it's natural to ask what prophetic statement *Us* means to deliver. Perhaps the movie's "shadows" serve as stand-ins for those, in our world, who suffer in order for others to prosper. Think of miners in developing countries, risking their lives for the materials that power our mobile phones. Or sweatshop laborers cranking out clothes in dangerous conditions, so that we can own forty shirts instead of five. Even the rabbits fit into this interpretation, reminding us that animal testing takes place in the manufacturing of certain cosmetics and hair-care products. With the literal, lamenting tears of a Jeremiah, *Us* challenges us to consider the ways our lifestyles come at the expense of others and how we might live differently in response.

*Us* was hardly the first horror film to prophetically denounce affluence, American affluence in particular. In 1991's *The People Under the Stairs*, from *Nightmare on Elm Street* and *Scream* director Wes Craven, a boy nicknamed Fool (Brandon Adams) tags along on a home robbery. The target: a deranged brother and sister (Everett McGill and Wendy Robie) whose mansion contains a collection of rare coins and, unbeknownst to the robbers, a cellar full of moaning, imprisoned ghouls. Fool joins the heist because his family is about to be evicted by the sister and brother, who own most of the property in Fool's impoverished ghetto and have greedily been driving up rents. Craven unnecessarily hammers home the racial and economic aspects of this setup with awkward dialogue and exposition, yet there is no denying the primal potency of some of the movie's imagery. Those lost souls in the basement—waving flashlights through the slats of their wooden cage, hands grasping for

freedom—particularly serve as potent metaphors for the exploited underclass on which the brother and sister feed.

Even further back, 1978's *Dawn of the Dead* is prophetic in its very setting. In this second zombie film from horror maestro George Romero (*Night of the Living Dead*), the survivors of an undead outbreak eventually find themselves barricaded in that most American of places: the shopping mall. After a brief period of unencumbered gluttony on the part of the survivors—everything in the mall is theirs for the taking, after all—the zombies break in. Romero's symbolism, then, works in multiple ways. Even as the undead, milling about mindlessly in the stores, stand in for zombified shoppers, the living learn a prophetic lesson: shopping can't save you.

## We the White People

Jordan Peele's first film, *Get Out*, exposes another idol: whiteness, or the preservation of a perverse social order based on the color of skin. The movie follows Chris Washington (Daniel Kaluuya), an African American photographer who accompanies his white girlfriend Rose (Allison Williams) on a weekend visit to her parents. She insists, "They are not racist." But it turns out they're worse: so sure that Black bodies exist for the gain and pleasure of white wishes that they've devised a macabre medical procedure in which the consciousness of a paying white client is transferred into the hypnotized body of a Black victim. The "buyer" for Chris, for example, is a former photographer who has gone blind and wishes to see the world through Chris's eyes.

As part of the process, Rose's mother Missy (Catherine Keener) hypnotizes Chris by speaking to him softly while stirring a spoon in a cup of tea. Immobilized, except for

the tears streaming down his face, Chris falls into what Missy calls the "sunken place"—envisioned by Peele and his production designers as a black void with a small window high above that offers the victim a distant peek at the real world.

Hypnotism of a sort is at play in *I Walked with a Zombie*, producer Val Lewton and director Jacques Tourneur's follow-up to 1942's *Cat People*. The film takes place on an island in the West Indies, where the mistress of a sugar plantation (Christine Gordon) has gone mysteriously mute, wandering about the estate as if she were sleepwalking. (She's the zombie of the title.) Some say her condition is the result of a fever, while others look with a fearful eye at the "voodoo" being practiced by the villagers. The truth, at least if you read the film as prophetic horror, is that the family who owns the plantation has fallen under judgment for the enslavement of people on which their wealth was founded—and their continued exploitation of those people in order to maintain their prosperity.

Early on in the movie, the plantation's owner, Paul Holland (Tom Conway), says this about the seemingly idyllic island: "There's no beauty here. Only death and decay." Yet he can't quite put a finger on the root of the disease. Later, he gets closer to the truth, pointing to a statue of Saint Sebastian in the plantation courtyard and explaining that it was "once the figurehead of a slave ship. That's where our people came from. From the misery and pain of slavery. For generations they found life a burden."

As in *Cat People*, Tourneur's camera casts a spectral spell, especially when it returns to that figurehead. Now the centerpiece of a fountain, with water dripping down it like a flood of tears (or blood), the image suggests that the curse the family is suffering from can be traced back to the boat from which "our people," as Paul describes them, came.

Slavery may no longer exist on the island, but the evil of white supremacy remains.

## We the Violent

There is a related American idol: violence. From historical chattel slavery to contemporary police brutality, violence is one of the tools by which whiteness is maintained. *The Purge*, released in 2013, imagines an alternate United States where the "New Founding Fathers" have declared that citizens can maim and murder at will, with no legal ramifications, for one designated day each year. While chaos reigns on the streets, wealthy citizens watch Purge Day from the comfort of their heavily fortified homes. Especially comfortable is James Sandin (Ethan Hawke), who has made a monetary killing by selling fortresslike security systems to affluent families like his.

During the Purge Day chronicled in the movie, however, things go awry. Sandin's son (Max Burkholder) lets a terrified, bedraggled, and beaten stranger (Edwin Hodge) into their house during purge hours. The stranger's bloodthirsty pursuers—well-off suburbanites like the Sandins, enjoying their own most dangerous game— demand that the Sandins release him, or else.

Written and directed by James DeMonaco, *The Purge* functions as a nasty piece of prophetic work—at least for its first half. Sandin instinctively wants to give the stranger up, even urging his wife (Lena Headey) to stick a letter opener in the man's open wound as they struggle to subdue him. When Sandin has a change of conscience, however, the movie's messages become mixed. As the Sandins bust out their personal artillery to fend off the preppy invaders, *The Purge* glorifies the very sort of violence it initially questioned.

Prophetic horror films can be particularly troubling because their terrors are too often directly reflected by the real world. Watching *The Purge*, I was reminded of Mark and Patricia McCloskey, the white couple who stood outside their Missouri mansion pointing guns at protestors marching down their street in June 2020. The cause that the marchers were championing? Racial justice, particularly in the aftermath of the police killing of George Floyd in May of that year.

Not all societal evils are as public as Floyd's death. As *Us* demonstrates, some sins lie closer to (our comfortable) home. Prophetic horror films, in the manner of the Old Testament prophets, speak truth both to power and our own hearts. There is an unsettling moment in *I Walked with a Zombie* in which Betsy Connell (Frances Dee), the nurse who has come to the island to care for the plantation's ailing mistress, is confronted by a troubadour (influential calypso singer Sir Lancelot). Emerging from the shadows, he sings a song of warning about the family's checkered history: "Ah woe, ah me. Shame and sorrow for the family . . ."

When we hear such songs—in our horror movies and elsewhere—may we respond not only with fear, but faithfulness, faithfulness to a God who calls us to be a people of peace, to celebrate the diversity of the nations, and to care about the comfort of others above our own.

# PSYCHOLOGICAL HORROR

## FEAR OF OUR ANXIETIES

"All children see monsters."
"Not like this."

That exchange, between a dismissive doctor and an overwhelmed mother, comes a third of the way into *The Babadook*, a 2014 Australian film from writer-director Jennifer Kent. Amelia (Essie Davis), the mother, is some six years removed from a traumatic event she has yet to fully process: the death of her husband in a car accident as he was driving her to the hospital to give birth to their son Samuel (Noah Wiseman). Now an energetic, imaginative young boy, Samuel's nervousness at night has been heightened by an eerie children's book about a malevolent spirit. Samuel thinks the Babadook is coming for him.

And maybe it is. In psychological horror films, we're never quite sure if the terrors we witness onscreen are actually happening or are taking place in the characters' heads. Often, it's a malleable mixture of both. What's certain, however, is that the horror being experienced functions as a metaphor for a particular anxiety. Perhaps it's trepidation over becoming a parent (as in *Eraserhead*,

which I also wrote about as an example of body horror). Maybe it's an uneasiness over the fading health of one's own parent (as in *Relic*, which I'll cover in this chapter). Whatever the anxiety, in a psychological horror film, such emotional distress curdles and coagulates until it manifests into an object of terror.

In her book *Anxious: Choosing Faith in a World of Worry*, Amy Simpson distinguishes between anxiety and fear. "In general, fear is a response to an immediate and known threat," she writes. "Anxiety is a response to a possibility."[1] I'd suggest that psychological horror movies, most of which operate on a slow burn, trace the way underlying anxieties balloon, eventually transforming into something we fear. What does it mean to "choose faith," even as the thing that we fear grows?

As Simpson stresses in her book, it's not simply a matter of slapping a comforting Bible verse on your refrigerator door. We might understand what Jesus means when he asks in Matthew 6:27, "Can any one of you by worrying add a single hour to your life?" And we can trust the apostle Paul when he tells us in Philippians 4:6–7, "Do not be anxious about anything, but in every situation, by prayer and petition, with thanksgiving, present your requests to God. And the peace of God, which transcends all understanding, will guard your hearts and your minds in Christ Jesus." But we can also admit that reading those words does little when we find ourselves dulled, say, by the dead weight of depression.

"Choosing faith" must mean something deeper, then. There must be a fuller understanding of God and God's love, even in the midst of our anxieties. Perhaps psychological horror films can help us get there.

1. Simpson, *Anxious*, 21.

## Mommy Is Mad

In *The Babadook*, it's Amelia's anxiety—as well as her depression—that becomes the focus, especially as Samuel's night terrors prevent her from getting an ounce of sleep. Davis gives a raw, prickly performance, gauntly portraying a woman at the end of her mental rope. She's aided by telling hair and makeup; even at work, where she cares for residents at a retirement facility, Amelia's hair is a frantic bird's nest. Evocative production design contributes, too. The interior of Amelia and Samuel's older, shabby home consists entirely of shades of gray, blue, and black: the trim work is black; the carpet running down the black stairs is a gloomy blue; and the walls are a blah gray. Even the linens on the beds are in the same palette, evoking Amelia's depressed mental state via an absence of bright color.

In such a condition, Amelia can't possibly attend to the needs of a child like Samuel, who is struggling with his own emotional challenges. She is as distressed as King David in Psalm 88:4: "I am counted among those who go down to the pit; I am like one without strength." The scariest moment in *The Babadook* comes when Amelia rests, completely spent, on her bed and Samuel enters the room whining that he is hungry. The camera focuses on her face in the foreground, while Samuel's figure stands in the background; we can see her sighs growing in fury until they build to an abusive outburst.

Throughout the movie, Amelia's repeated refrain—"I just need to sleep"—is something I said many times as a young father, after multiple nights of diaper changes/high temperatures/nightmares. As Amelia begins to fear that the Babadook might be real—indeed, might be feeding her worst impulses—the movie considers the dark side that any bone-weary parent can sometimes feel creeping up within.

*Relic*, another Australian horror effort, reverses the family dynamic. In director Natalie Erika James's 2020 film, which she co-wrote with Christian White, it's a grown daughter, Kay (Emily Mortimer), who is crumbling under the weight of caring for her aging mother, Edna (Robyn Nevin). Kay, along with her college-aged daughter Sam (Bella Heathcote), has temporarily moved in with Edna in her country home after a series of concerning incidents (as when Edna flooded the house by forgetting to turn off the water in the bathtub). The specter of dementia hangs over Kay's family—there are grisly, flitting flashbacks to a great-grandfather who died alone in a cabin on the property—and Kay fears her mother is next. The moldy blots of rot on the house's walls only stoke these concerns.

In *Relic*, dementia is a demonic force, one the movie literalizes at the very start. Notice in the prologue—in which a doddering Edna stares at a Christmas tree in her living room, the lights slowly blinking like fading synapses—that a shadowy figure appears to be sitting in an armchair in the corner. Later, a similar figure seems to be standing behind Kay when she investigates a sound in the middle of the night. These horror touches connect with other moments that are far more mundane, as when Sam peels potatoes while watching Edna use a knife to carve wax from the strange, fleshy candles she makes as a hobby. The linked actions suggest that whatever is happening to Sam's grandmother might be an inherited trait. Will the demon of dementia eventually come for Sam?

## (Don't) Leave Daddy Alone

If dementia (and the anxiety that accompanies it) is the clear monster in *Relic*, it's difficult to identify a central specter in *The Lighthouse*, an exercise in psychological horror from

*The Witch* filmmaker Robert Eggers. An amalgamation of Greek mythology, Catholicism, and seafaring lore, the movie follows two lighthouse keepers who are dumped on a craggy rock in 1890s New England for a four-week stint: grizzled, bearded veteran Thomas Wake (Willem Dafoe) and fresh-faced novice Ephraim Winslow (Robert Pattinson). As the days drag on past their pickup date, with no relief boat in sight, all sorts of anxieties begin to monstrously bloom. "Doldrums, doldrums," the older Wake grumbles. "Eviler than the Devil."

*The Lighthouse* evokes these "doldrums" in striking, cinematic ways. The first sound we hear is that of a foghorn; in fact, throughout the film, its low, persistent moans can be heard in the background, echoing those anxious thoughts that are always burbling underneath our consciousness. Working with cinematographer Jarin Blaschke, Eggers shot the film in bleak black and white, employing a boxy, 1.19:1 aspect ratio reminiscent of silent cinema. When we look into the square opening of a dirty cistern, then, we're boxed in twice—by the watery hole and the actual frame of the screen. The film's very design is, again, reminiscent of Psalm 88:4: "I am confined and cannot escape."

In *The Shining*, Stanley Kubrick's adaptation of the Stephen King novel, Jack Torrance (Jack Nicholson) is another lonely, isolated man experiencing a severe case of the doldrums. Hired as the offseason caretaker of a vast resort hotel, Jack hopes the peace and quiet will allow him to work on a writing project. His wife, Wendy (Shelley Duvall), and young son, Danny (Danny Lloyd), are left to wander the endless halls. Jack keeps typing away, although as Wendy discovers when she investigates his desk, he hasn't been very productive. "All work and no play makes Jack a dull boy," the pages read, over and over and over.

I still struggle with Nicholson's outsized performance, which only grows bigger as Jack descends further into madness. Yet on an October 26, 2012 episode of *Filmspotting*, my co-host and the show's executive producer, Adam Kempenaar, made an incisive connection between Nicholson's portrayal and *The Shining* as a work of psychological horror. "This really is a film about repression," Kempenaar said. "There is this psychological terror I think Kubrick is exploring that can come from someone repressing themselves, from stifling their natural urges and desires. . . . This idea that [Jack Torrance] has to just be a father who has to collect a paycheck. He doesn't get to do the fun things he wants to do. It is an expression of him being stifled in some way."[2]

I love the details of Jack's typed manuscript, which Kubrick captures in close-up: there are typos in some of the lines ("dull bot" and "dull bog" alongside "dull boy"); other pages have been formatted like a novel, with paragraphs and indented segments, even though the words are all the same. Watching the scene of Wendy reading these pages, I thought of the moment in *The Lighthouse* where Ephraim gets his hands on Thomas's logbook, in which he discovers critical comments relating to the quality of Ephraim's work. Both manuscripts are ledgers judging the respective men as failures.

## Reaching Out

In the collection *A Room Called Remember*, Frederick Buechner considered the rise of interest in supernatural stories, particularly among young people, and wrote, "Being scared is fun in itself, and when what you are scared by is an externalization *out there* on the printed page of something

2. Kempenaar, "Filmspotting #419," October 26, 2012.

even scarier *in here* where your bad dreams come from, there is perhaps a kind of therapy in it too."[3]

I'd push Buechner further. Therapy is good. It is certainly called for in times of overwhelming anxiety, alongside other means of modern medicine. But I think psychological horror can be more than simply one facet of a health-treatment plan. Such films offer spiritual consolation too.

In the climactic moment of *The Babadook*, after Amelia has given in to her most evil urges, ragefully pursuing Samuel with full intent to harm him, the poor boy manages to trip his mother into the basement of their gloomy home. He ties her up, yet he doesn't flee. "I love you, Mom," he says. "I always will." Still under the thrall of the Babadook, she manages to free herself enough to grab him. But even then, as she chokes the poor child, he lightly touches her face. The gesture of affection breaks the spell and Amelia relents, rolling over and spewing forth a torrent of black, poisonous goo.

God's love is in Samuel's light touch. As deep as our anxieties feel—even as they urge us to rage against those we love and the God who loves us—God will still reach out in compassion. God will not let go, even if we've lost our minds. For this reason, Paul's words in 2 Corinthians 4:8–9 should center us, whether or not we put them on our fridge: "We are hard pressed on every side, but not crushed; perplexed, but not in despair; persecuted, but not abandoned; struck down, but not destroyed."

At the end of *The Babadook*, Amelia—free from her rage and reunited with a loving Samuel—reveals that the Babadook now resides in their basement, fed by her with the occasional meal of worms but not allowed to come upstairs. Our anxieties, in this life, will always be with us. But God's love is eternal.

3. Buechner, *Room Called Remember*, 161.

# GHOST STORIES

## FEAR OF GUILT

"What is a ghost?"

This question, posed in unidentified voice-over, opens *The Devil's Backbone*, a Spanish-Mexican co-production set at an orphanage during the Spanish Civil War. The disembodied voice goes on to offer some potential answers: "A tragedy doomed to repeat itself time and again? An instant of pain perhaps? Something dead which still seems to be alive? An emotion suspended in time . . . like a blurred photograph . . . like an insect trapped in amber . . ."

In the Bible, ghosts are many things. In Isaiah 14:3–23, the prophet describes a vision in which the king of Babylon will be tormented by "the spirits of the departed." In 1 Samuel 28:3–19, King Saul unwisely rouses the ghost of Samuel. Twice in the Gospels—before the resurrection in Matthew 14:26 and afterwards in Luke 24:36–43—the disciples mistake Jesus for a ghost, suggesting such superstition was part of the culture. These moments are mostly asides. The one time Scripture directly comments on the idea of ghosts, in Deuteronomy 18:10–11, it's within a larger admonition, telling us not to mess with them: "Let

no one be found among you who sacrifices their son or daughter in the fire, who practices divination or sorcery, interprets omens, engages in witchcraft, or casts spells, or who is a medium or spiritist or who consults the dead."

Dr. Casares (Federico Luppi), a science-minded instructor at the orphanage in *The Devil's Backbone*, scoffs at the concept of ghosts even though the boys who live there tell stories about the spirit of a dead child, whom they call "the one who sighs." Asked by a student if he believes in ghosts, Dr. Casares replies, "Spain is full of superstition. Europe is sick with fear now, and fear sickens the soul. And that, in turn, makes us see things."

## Sackcloth and Ashes

In ghost stories, what we see—and what we essentially fear—is often a manifestation of guilt. This is gruesomely envisioned in *The Devil's Backbone* by director Guillermo del Toro, an accomplished chronicler of the whimsically macabre (his other pictures include *Pan's Labyrinth* and *The Shape of Water*, the latter of which won the Best Picture Oscar in 2018). "The one who sighs"—or Santi (Junio Valverde), as we come to know the child ghost—suffers from a ghastly head wound, out of which billows a diffuse cloud of blood. This grisly plume hovers above Santi whenever he appears, a symbol of the responsibility which someone at the orphanage bears for his death.

In 2007, six years after *The Devil's Backbone*, another ghost story was released involving orphaned children in Spain. Executive produced by del Toro and directed by J. A. Bayona, *The Orphanage* multiplies both the ghosts and the guilty. We learn early on that a group of murdered children haunt the halls of this orphanage. Their killer, a woman who worked there, committed the heinous act in revenge,

as a deranged attempt to avenge her disfigured son, who died as the result of a prank pulled on him by the other kids. (The ghostly figure of her son, wearing a burlap scarecrow's sack in order to cover his malformed face, has caused me many sleepless nights.) In *The Orphanage*, there's plenty of blame to go around; the home's walls seem swollen with it.

All of this is backstory for the narrative proper, set a few decades after the children's deaths. The main character in *The Orphanage* is Laura (Belén Rueda), a woman who hopes to revitalize the now-shuttered facility as a home for kids with special needs. When her son Simón (Roger Princep) makes contact with the young ghosts, ultimately resulting in his death, Laura blames herself—eventually to the point of suicide. *The Orphanage* ends with a homey vision that offers little comfort: Laura as the ghost mother to all the dead children, a family of spirits mourning their guilt and victimhood together for the rest of time.

## Unforgiven and Unearthed

We're familiar with ghosts who haunt the halls of gothic mansions and spooky schools, but what about computers? That's the conceit of *Unfriended*, a 2015 ghost story that still scares despite the advances in technology that have taken place since its release. The movie's exploration of guilt, specifically within the context of a teenager's online life, continues to resonate no matter what device, app, or social media platform happens to be in fashion.

*Unfriended* takes place entirely on the laptop screen of Blaire (Shelley Henning), a teen whom we watch video chatting with a group of friends. Before the call begins, we see Blaire viewing video footage from a year earlier, in which her classmate Laura (Heather Sossaman) died by suicide after suffering a cruel instance of cyberbullying.

Blaire quickly shuts off the video when her friends sign on, hoping to move on from the memory. But then an anonymous caller joins the video chat and starts goading the others into dredging up their shared past. At the same time, Blaire receives Facebook messages from Laura's defunct account. Is this a tech-savvy troll, one of the friends messing with the others in the group, or something more sinister? Frantically scouring the Internet in one corner of her screen, Blaire comes across a website with a warning that echoes Deuteronomy: "Do Not Answer Messages From the Dead."

Written by Nelson Greaves and directed by Levan Gabriadze, *Unfriended* takes seemingly benign technology and turns it into a vehicle for menace. When Blaire stares at her Facebook message window and sees this text— "Laura is typing . . ."—it's no longer simply information, but a terrifying threat. That blank, faceless avatar for the anonymous caller on the video chat becomes almost as scary as *The Orphanage*'s burlap sack. And whenever the video buffers, it makes the friends' figures creepily pixelated. As they fade in and out, it's as if they're all ghosts.

There is another formal element to *Unfriended* that's ingeniously handled: the "editing." The movie manages to wring suspense and emotional resonance by choosing which onscreen window to maximize or by picking the precise moment to have a certain notification alert pop up. Even the various ways Blaire operates her apps—quickly, slowly, or with hesitation—carry different emotional connotations. I've never been so wrung out waiting for the click of a computer key.

*Unfriended* employs such artistry toward an increasingly theological exploration of guilt. At one point, the unseen presence sends this message to the group: "You each have dirty little secrets. I want to expose them." Then

later: "You're all terrible people." It's an accusation that resonates with the claim of the apostle Paul in Romans 3:23, that "all have sinned and fallen short of the glory of God."

On the same website that gave Laura the Deuteronomic warning, she finds another article: "To Free Yourself You Must Confess." Yet like all of us, she doesn't find this to be easy. Her direct messages to the ghost slowly, reluctantly emerge from her fingertips, full of backtracking and equivocation: "this wasn't us" . . . "we didn't mean it" . . . "we made a mistake" . . . "but we're good people." The ghost's eventual response is the opposite of the love and mercy Paul also writes about in Romans 3:24, the reality that we "are justified freely by his grace through the redemption that came by Christ Jesus." In *Unfriended*, the ghost only says, "I wish I could forgive you Blaire." This is yet another ghost story that delivers vengeance, but no spiritual catharsis.

Given that *Poltergeist* came out in 1982, the technology at the center of the film is even more dated than that of *Unfriended*. Here, the ghosts connect with the living via a television set. Specifically, they communicate with little Carol Anne Freeling (Heather O'Rourke), who wanders in front of the TV in her parents' bedroom late at night after the networks' regular programming has given way to nothing but static. (Yes, there was once a time when the "content" spout actually shut off.) As Carol Anne stares into the set's crackling void, spectral tendrils seep out from the screen. A blast burns a hole through the wall behind her, and her parents' bed begins to shake. When they wake, startled, she cheerily announces, "They're heeeere."

We eventually learn the reason for this visit. It turns out the newly constructed subdivision that the Freelings live in was once the site of a massive cemetery; the developers took away the gravestones, but left the bodies. As the

Freelings were the first to move into the neighborhood—Carol Anne's father (Craig T. Nelson) happens to be the lead salesman for the development—the ghosts take their complaints to them.

Directed by Tobe Hooper of *The Texas Chain Saw Massacre* fame—working from a script by Michael Grais, Mark Victor, and producer Steven Spielberg—*Poltergeist* is sly about revealing its sins. During the opening credits, to the gentle strains of Jerry Goldsmith's idyllic score, the camera pans over this lush, stolen valley. But notice that none of the trees have leaves; they're dead. This is echoed by the massive, barren tree that stands in the Freelings' backyard. Steve, the father, describes it as "a very wise old tree," but his skeptical young son (Oliver Robins)—outside whose window the craggy branches reach—sees it as a threat. Even the pool that the Freelings are having installed—that crowning achievement of any respectable suburban oasis—has a dark side, in that it also functions as an emblem of manifest destiny. This is suggested in a throwaway shot of a bulldozer unearthing the cigar box in which Carol Anne and her mother (JoBeth Williams) had buried a pet bird just a few scenes earlier.

*Poltergeist* wisely saves its reveal of the ghosts' motivations until far later in the film, after Carol Anne has been sucked into a spectral vortex in her closet and the Freelings have enlisted a team of paranormal researchers to help retrieve her. Steve's boss (James Karen) stops by—Steve has been missing work and there are homes to sell—and drives Steve to the top of a hill that will be the site of the next phase of the development (never mind that a second cemetery also stands on this parcel). Like Satan atop the mountain making promises to Jesus in Matthew 4, Mr. Teague offers Steve a new home on that very spot—as long as he keeps those sales figures churning. When Steve notes

that relocating the cemetery would be "sacrilegious," Mr. Teague responds: "It's not ancient burial ground . . . besides, we've done it before."

I wish *Poltergeist* had pushed that reference to Native Americans further and acknowledged, in some additional way, that vast stretches of the United States consist of stolen and disrespected ground. (*Poltergeist II: The Other Side* features a Native American character, but similarly fails to follow through on the implications.) If *Poltergeist* had half of the social commentary of *The People Under the Stairs*—another parable of property exploitation—it would count as prophetic horror in addition to being a ghost story.

## Resting in Peace

History haunts the edges of *Poltergeist*. In *Beloved*, director Jonathan Demme's 1998 adaptation of Toni Morrison's Pulitzer Prize-winning novel, history—both corporate and personal—appears as the dominant evil.

Oprah Winfrey stars as Sethe, a mother of four who escaped enslavement and resettled in the free state of Ohio. Tracked down there by her former overseer, she made a terrible decision: rather than relinquish her children back to the hell of the plantation, Sethe cut the throat of her baby girl. Years later, though free with her surviving children in Ohio, Sethe is haunted by the dehumanizing memories of her life of enslavement, as well as guilt over her awful act. Eventually, these twin traumas become embodied in the form of Beloved (Thandiwe Newton), the grown ghost of the daughter Sethe murdered.

In *Reading Black Books: How African American Literature Can Make Our Faith More Whole and Just*, Claude Atcho writes that "Sethe's mind is gorged so full of traumatic memories that she laments her 'greedy

brain,' which continues to house horror upon horror."[1] In the movie, Demme and cinematographer Tak Fujimoto evoke this by employing frequent dissolves, in which the past literally bleeds onto the screen, infecting the present. Regularly, the house Sethe lives in pulses with a throbbing red. "How might Black Christians specifically process the terror of history in both our personal and ancestral suffering?" Atcho asks in his book. "What does healing look like for those reckoning with unspeakable pain bred in the marrow of memory?"[2]

As difficult as it is to watch *Beloved*—its depictions of Sethe's suffering on the plantation are all the more horrifying for being based in historical fact—the movie has a sense of hope that ghost stories like *The Devil's Backbone*, *The Orphanage*, and *Unfriended* lack. After Beloved has taken over her home, Sethe is saved by her loving community. A group of women march to her house, singing songs and demanding that Beloved release Sethe. Amidst the cries of exorcism, one of the women can be heard wailing, "I heard the voice of Jesus say, 'Come unto me and rest!'"

"Healing, then, can become actual only when the dangerous thing is done: the trauma of memory is brought to the light and remembered right," Atcho writes in *Reading Black Books*.[3] I take this to mean that we remember not in order to wallow in our trauma and guilt, but as a purposeful act of justice-seeking and, if necessary, confessional purging.

Healing, not haunting, is also the primary aim of *The Sixth Sense*, the third feature film from writer-director M. Night Shyamalan and the one that launched his reputation as a twisty storyteller.

1. Atcho, *Reading Black Books*, 112.
2. Atcho, *Reading Black Books*, 110.
3. Atcho, *Reading Black Books*, 125.

In *The Sixth Sense*, it's the ghost who's guilty—although first-time viewers don't realize that until late in the movie. At first, we focus on Haley Joel Osment's Cole Sear, a skittish boy who sees ghosts who don't realize that they're dead. Among these phantoms is child psychologist Malcolm Crowe (Bruce Willis). Shot and killed by a former patient who suffered from the same condition as Cole, Crowe has refused to accept his own death. Instead, he's latched onto Cole as a way to make up for his earlier failure.

It's interesting that the Bible has far more verses about relieving us of such guilt than it does about ghosts. Among the most beautiful are David's words in Psalm 103:9–10, where he praises a God who "will not always accuse, nor will he harbor his anger forever; he does not treat us as our sins deserve or repay us according to our iniquities." The prophet Micah assures us, in Micah 7:19, that God will "hurl all our iniquities into the depths of the sea." This washing away of our transgressions is the heart of the gospel message of the New Testament, perhaps most blessedly delivered in Romans 8:1: "Therefore, there is now no condemnation for those who are in Christ Jesus . . ."

All of us need these assurances, no matter how minor our offenses. I think back to the time my older daughter was in elementary school, maybe second or third grade, when my wife and I would dutifully pack a vegetable of some kind in her lunch. Sugar snap peas were the green of choice for a season and we were pleasantly surprised to find, at the end of each day, her little vegetable container empty. It wasn't until many weeks later that she burst into tears, completely distraught, and confessed that she had been letting an older girl on the bus eat them every day. The infraction was small; the guilt was real.

Malcolm seeks relief from even greater shame in *The Sixth Sense*—although his guilt is somewhat misplaced.

Throughout the movie, we see Malcolm attempting to interact with his wife (Olivia Williams), but she either ignores him, looks past him, or falls asleep when he's in the room. It isn't until *The Sixth Sense*'s big reveal that we realize she cannot see him because he is a ghost. And it isn't until he's been repeatedly ignored in such moments—scenes blocked and framed by Shyamalan with a clever sleight of hand, so that it seems as if the characters are occupying the same space—that Malcolm understands his true failure. It was not that he failed his former patient, to whom he gave his all, but that he failed his wife by not prioritizing their relationship over his work when he was alive.

Malcolm makes his confession to Cole even before he fully realizes that he's a ghost: "I can't be your doctor anymore. I haven't paid enough attention to my family. Bad things happen when you do that." The relief he finds opens his eyes to the truth of his unearthly state. After the initial shock, Malcolm finds peace. As his wife sleeps, he tells her, "I think I can go now. I just needed to do a couple of things. I needed to help someone. I think I did. And I needed to tell you something: You were never second. Ever. I love you. You sleep now. Everything will be different in the morning."

This may seem to conflict with the Christian understanding of grace, as if Malcolm has done the right things, taken the proper steps, and earned his rest. But I like to think of it as a gift, given to him by Cole, a surprise as unexpected as any Shyamalan twist. This gift awaits every guilty one of us, even those who didn't eat their peas. Horror movies may not be able to offer the gift of God's grace, but the best of them, between the scares, can remind us that it's sitting there, just waiting to be received.

# CONCLUSION

This is less of a conclusion than an apology. I'm sorry I didn't write about (insert your favorite horror movie here). And I'm chagrined that I wasn't able to include chapters on other crucial subgenres: giallo, Japanese horror, Hammer horror, etc.

As I mentioned in the Introduction, this book is intended as an entry point for thinking theologically about horror films, rather than a comprehensive assessment of the genre. What's more, the particular theological lens that I apply—examining how certain fright films artfully resonate with our fears and, in some cases, hint at God's redemptive comfort—means movies that didn't fit the framework were left out.

I want to stress that this approach is not the only way to think Christianly about horror movies. This book is not meant to be any sort of final word, but rather one way to start a conversation. So let's talk. Let me know what movies you wish I had included—and tell me what particular fears you think those films explore. Connect with me on Twitter @larsenonfilm, using the hashtag #FearNotFilmBook. I'm eager to hear your fears—and hopes.

# BIBLIOGRAPHY

Atcho, Claude. *Reading Black Books: How African American Literature Can Make Our Faith More Whole and Just*. Grand Rapids: Baker, 2022.

Best, Isabel, ed. *The Collected Sermons of Dietrich Bonhoeffer, Volume 1*. Minneapolis: Fortress, 2012.

Buechner, Frederick. *A Room Called Remember*. New York: Harper & Row, 1984.

Callaway, Kutter, and Barry Taylor. *The Aesthetics of Atheism: Theology and Imagination in Contemporary Culture*. Minneapolis: Fortress, 2019.

Davis, Kimberly. "The New Technology of Social Justice." https://thinkchristian.net/the-new-technology-of-social-justice.

Feenstra, Ronald J. "The Resurrection of the Body." https://www.thebanner.org/departments/2011/01/the-resurrection-of-the-body.

Fields, Bruce L. "The Black Church (Prophetic) View." In *Five Views on the Church and Politics*, edited by Amy E. Black and Stanley N. Gundry, 97–124. Grand Rapids: Zondervan, 2015.

Fragoso, Sam. "TIFF 2015: Stonewall, Louder Than Bombs, The Final Girls." https://www.rogerebert.com/festivals/tiff-2015-stonewall-louder-than-bombs-the-final-girls.

Greydanus, Steven D. "Interview: Filmmaker Scott Derrickson on Horror, Faith, Chesterton and *Deliver Us From Evil*." http://decentfilms.com/articles/interview-scott-derrickson.

Keller, Catherine. *Face of the Deep: A Theology of Becoming*. New York: Routledge, 2003.

Kempenaar, Adam. "Filmspotting #419: *The Shining* / Terrifying Characters / *Room 237*." Podcast. October 26, 2012. https://

www.filmspotting.net/episodes-archive/2012/10/26/419-the-shining-terrifying-characters-room-237.

*Lectio 365*. "Matthew 26:36–39." https://www.24-7prayer.com/resource/lectio-365/.

Lewis, C. S. *The Screwtape Letters*. San Francisco: HarperOne, 2015.

Nelson, Roger. "Industries of Fear." https://media.hope-crc.org/2022-01-09-Industries-of-Fear.pdf.

Rockett, Will H. *Devouring Whirlwind: Terror and Transcendence in the Cinema of Cruelty*. Westport, CT: Greenwood, 1988.

Sellers, Tina Schermer. *Sex, God, and the Conservative Church: Erasing Shame From Sexual Intimacy*. New York: Routledge, 2017.

Simpson, Amy. *Anxious: Choosing Faith in a World of Worry*. Downers Grove, IL: InterVarsity, 2014.

Strickland, Danielle. *The Zombie Gospel: The Walking Dead and What It Means to be Human*. Downers Grove, IL: InterVarsity, 2017.

Taylor, Barbara Brown. *When God Is Silent*. Lanham, MD: Cowley, 1998.

Zilko, Christian. "Robert Eggers Envies Medieval Craftsmen, Says It's Hard to be Creative in Modern Secular Society." https://www.indiewire.com/2022/06/robert-eggers-modern-society-1234733111/.

# INDEX OF MOVIE TITLES

28 Days Later, 20, 23–24
28 Weeks Later, 24
As Above, So Below, 65–67

The Babadook, 85, 87, 91
Beloved, 98–99
The Birds, 27, 30, 33–35
The Blair Witch Project,
    61–63, 65

Candyman (1992), 39, 72
Candyman (2021), 39, 72
Cat People (1942), 54–55, 82
Cat People (1982), 56
The Conjuring, 44–45, 48, 52
Crash (1996), 72
Crawl, 29, 33
Creature from the Black
    Lagoon, 12, 15
Crimes of the Future, 72

Dawn of the Dead, 21, 81
The Devil's Backbone, 92–93,
    99
Dracula (1931), 12–13,
    15–17, 53

Eraserhead, 74–75, 85
eXistenZ, 72

The Exorcism of Emily Rose,
    6, 48
The Exorcist, 5, 47–49

The Fly (1986), 69–72, 75
Frankenstein (1931), 12,
    14–16, 70
Friday the 13th (1980), 38,
    54, 56–57, 59–60

Ganja & Hess, 49, 50–52
Get Out, 79, 81
Godzilla (1954), 27, 30–32

Halloween (1978), 38–39, 54,
    56–58
Hellraiser (1987), 72–73
The Host, 31–32, 34

The Invisible Man (1933), 12,
    14, 17
It Follows, 58–60
I Walked with a Zombie, 82,
    84

Jaws, 28–30, 33–34
Jurassic Park, 30, 32–34

The Lighthouse, 88–90

# Index of Movie Titles

The Mummy (1932), 12, 14

Night of the Living Dead, 3, 20–22, 50, 81
A Nightmare on Elm Street (1984), 36, 38, 42–43, 54, 80
The Orphanage, 93–95, 99

Paranormal Activity, 63, 65
The People Under the Stairs, 80, 98
Poltergeist, 96–98
Poltergeist II, 98
The Purge, 83–84
Psycho (1960), 2, 40

Raw, 73–74
REC, 64
Relic (2020), 86, 88

Scream (1996), 38, 80

Shaun of the Dead, 21, 23–24
The Shining, 2–3, 89–90
The Sixth Sense, 99–101

Tetsuo: The Iron Man, 74–75
The Texas Chain Saw Massacre (1974), 3, 40, 59, 97
Them!, 30–31
Train to Busan, 19–21, 24, 26

Unfriended, 94–96, 99
Us, 77–80

Videodrome, 72

Whose Streets?, 66–67
The Witch, xi, 46–47, 89
The Wolf Man (1941), 11–12, 16, 18

X, 59–60